SIMPSONS™ COMICS CLUBHOUSE

HARPER

NEW YORK · LONDON · TORONTO · SYDNEY

SIMPSONS COMICS CLUBHOUSE

Materials previously published in
Simpsons Comics #109-111, and The Simpsons Summer Shindig #4-5

Copyright © 2015 by
Bongo Entertainment, Inc. All rights reserved.

FIRST EDITION

ISBN 978-0-06-236060-1

15 16 17 18 19 TC 10 9 8 7 6 5 4 3 2 1

Publisher: Matt Groening
Creative Director: Nathan Kane
Managing Editor: Terry Delegeane
Director of Operations: Robert Zaugh
Art Director: Jason Ho
Art Director Special Projects: Serban Cristescu
Assistant Art Director: Mike Rote
Production Manager: Christopher Ungar
Assistant Editor: Karen Bates
Production: Art Villanueva
Administration: Ruth Waytz, Pete Benson
Legal Guardian: Susan A. Grode

Printed by TC Transcontinental, Beauceville, QC, Canada. 11/24/2014

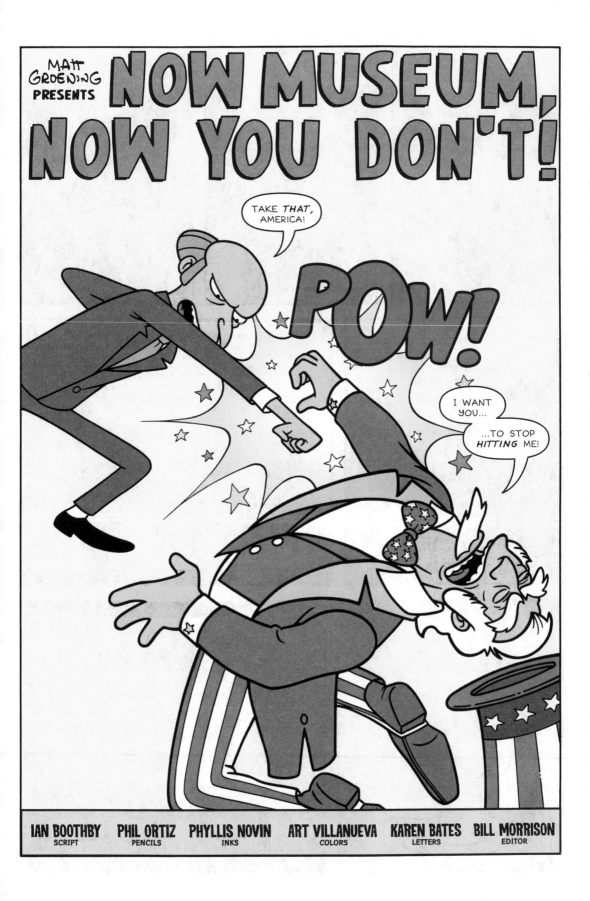

MATT GROENING PRESENTS

NOW MUSEUM, NOW YOU DON'T!

IAN BOOTHBY
SCRIPT

PHIL ORTIZ
PENCILS

PHYLLIS NOVIN
INKS

ART VILLANUEVA
COLORS

KAREN BATES
LETTERS

BILL MORRISON
EDITOR

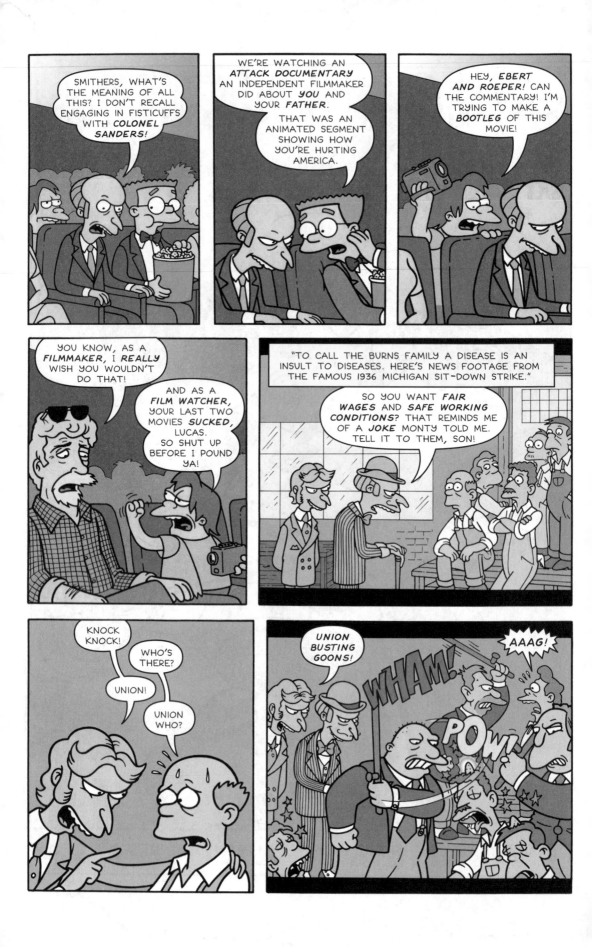

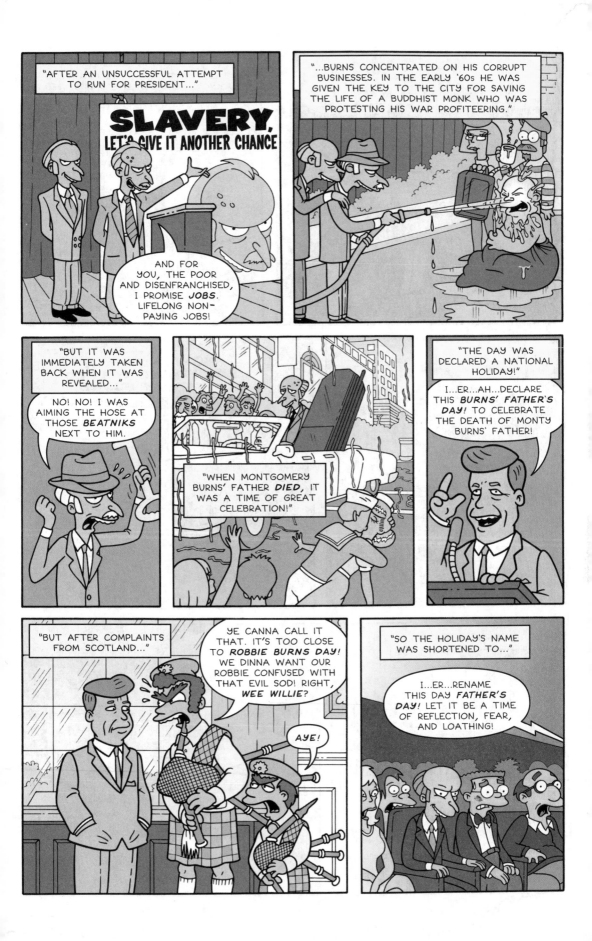

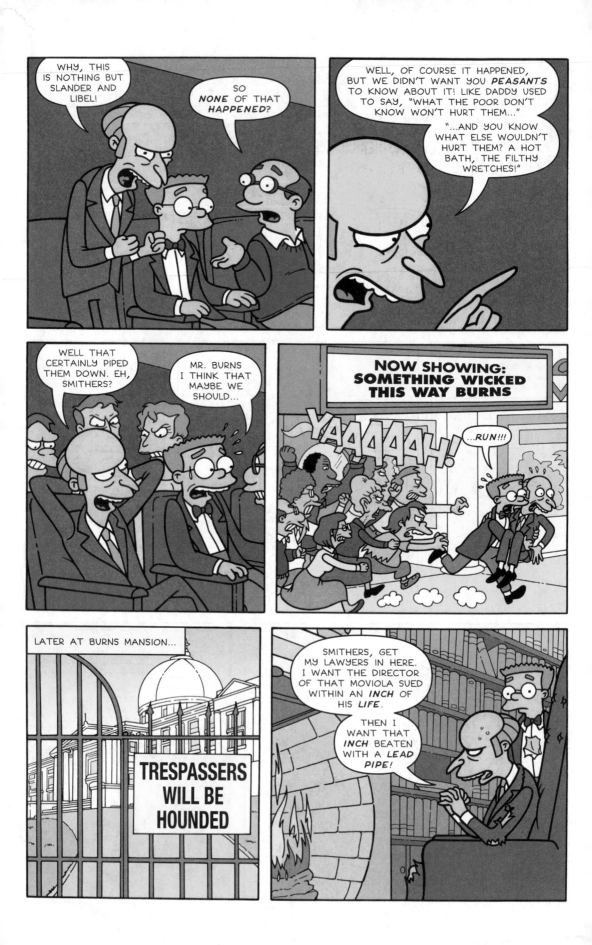

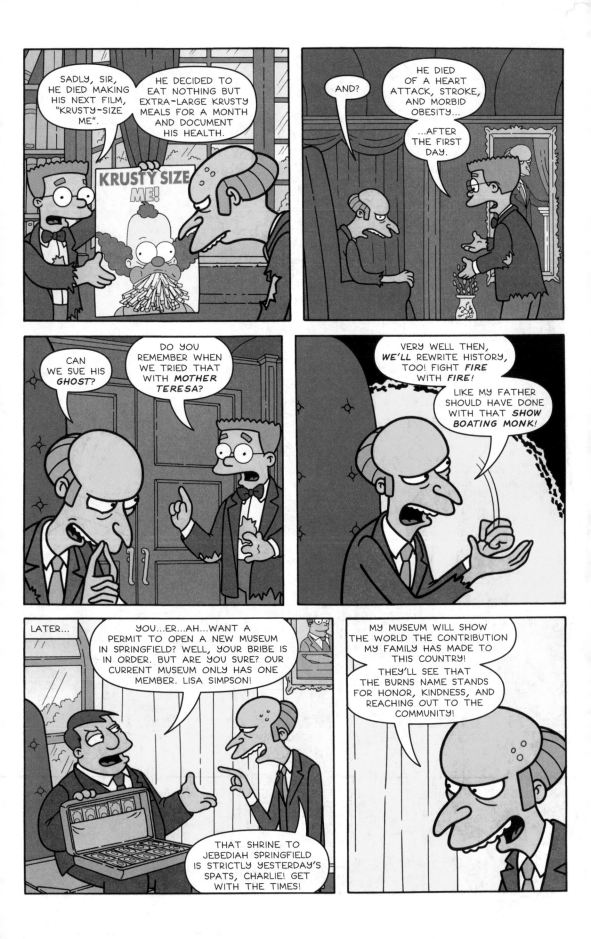

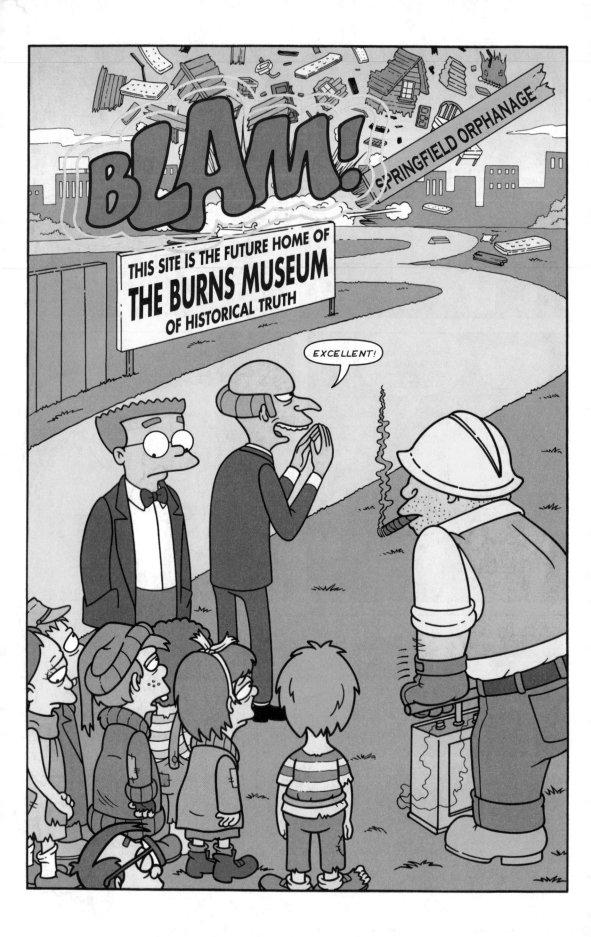

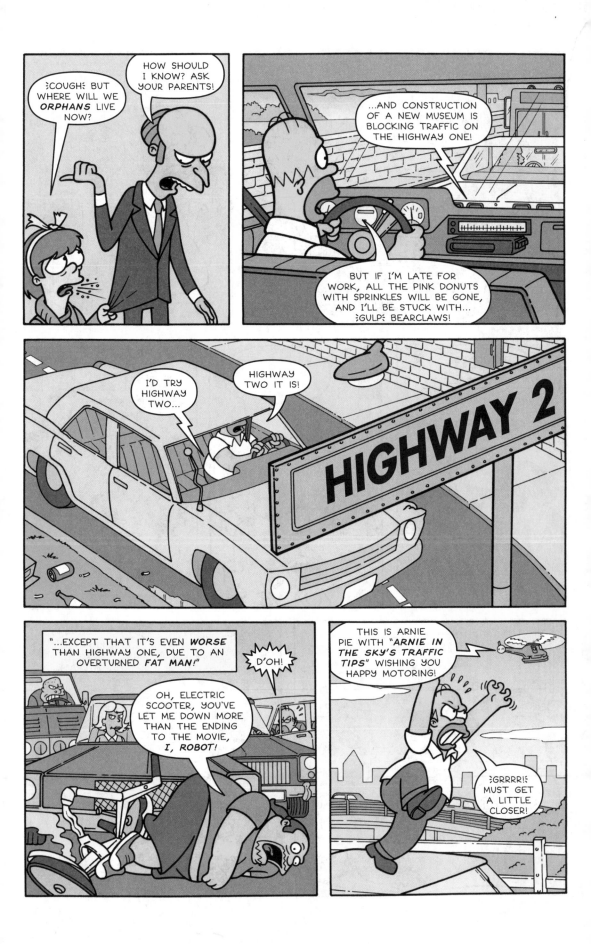

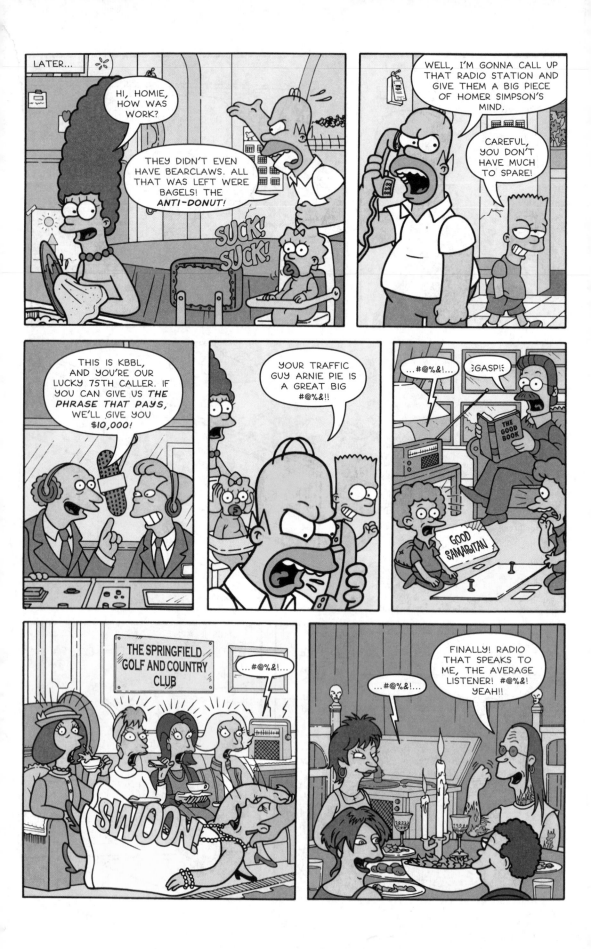

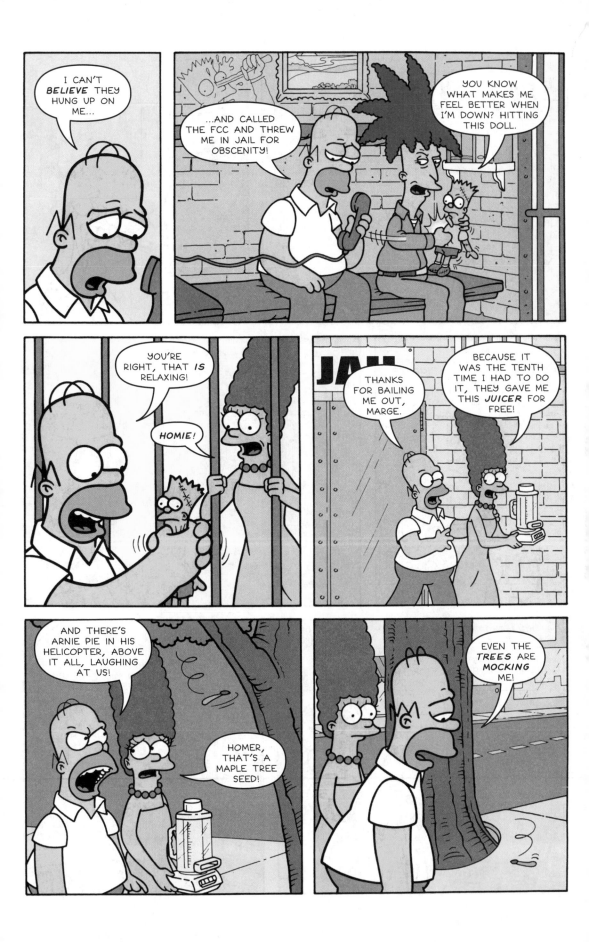

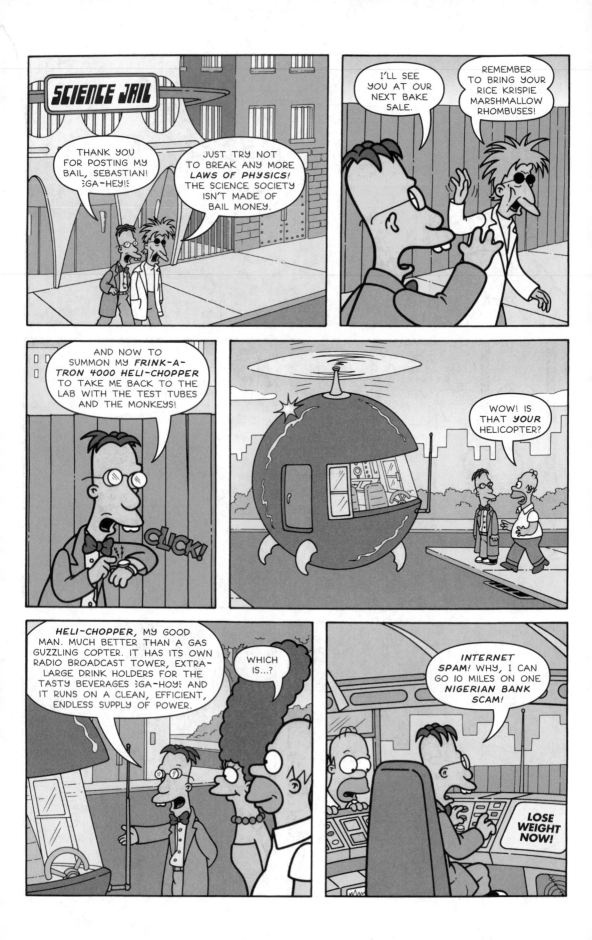

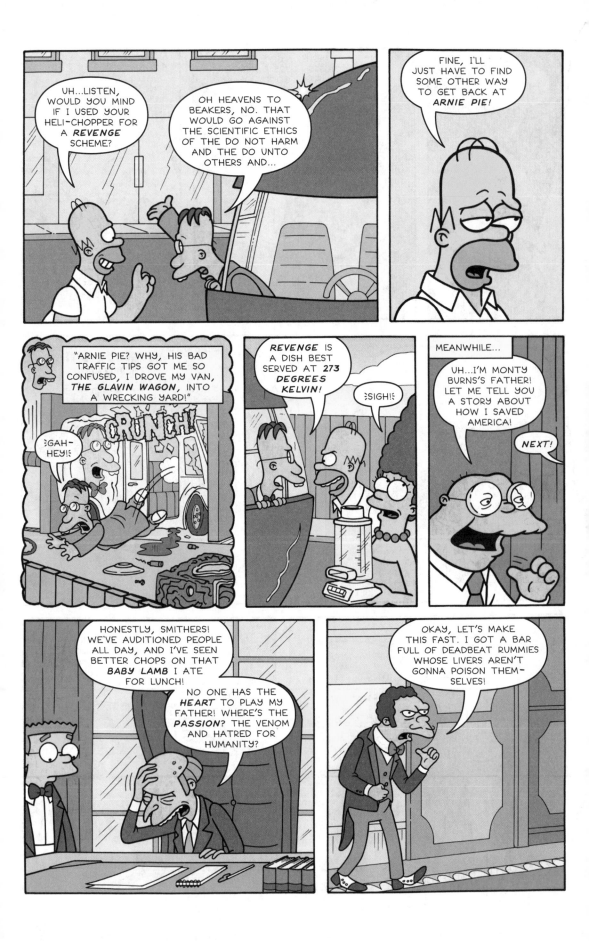

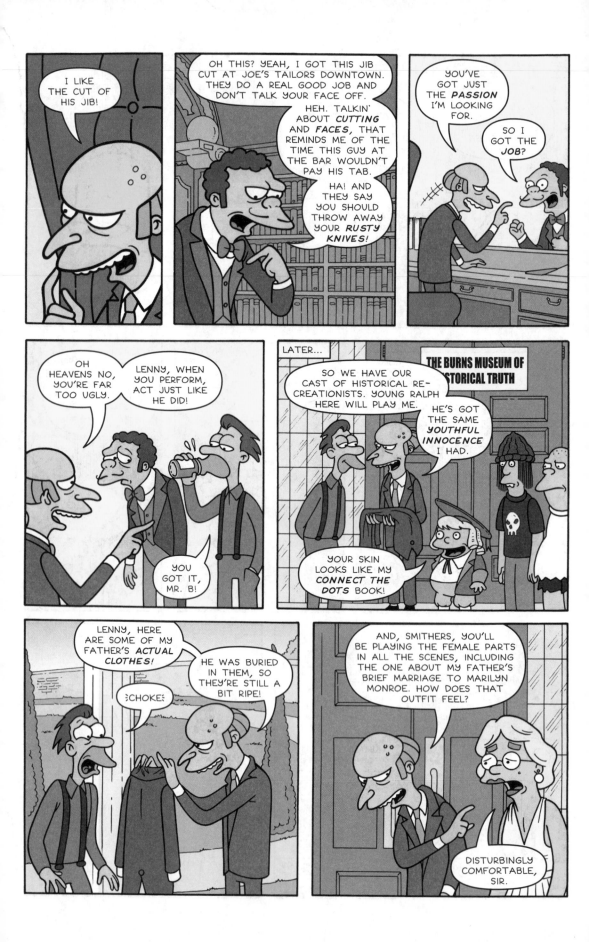

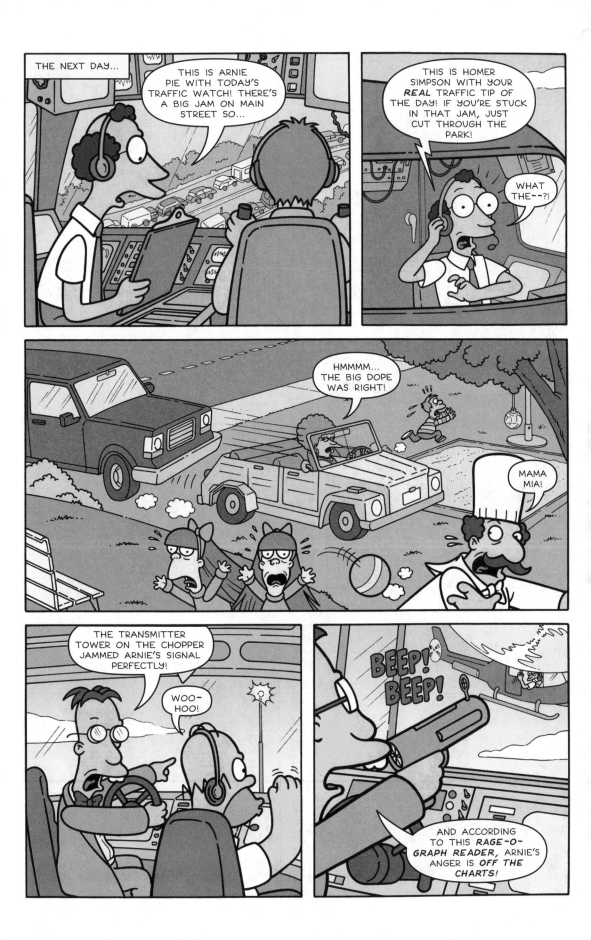

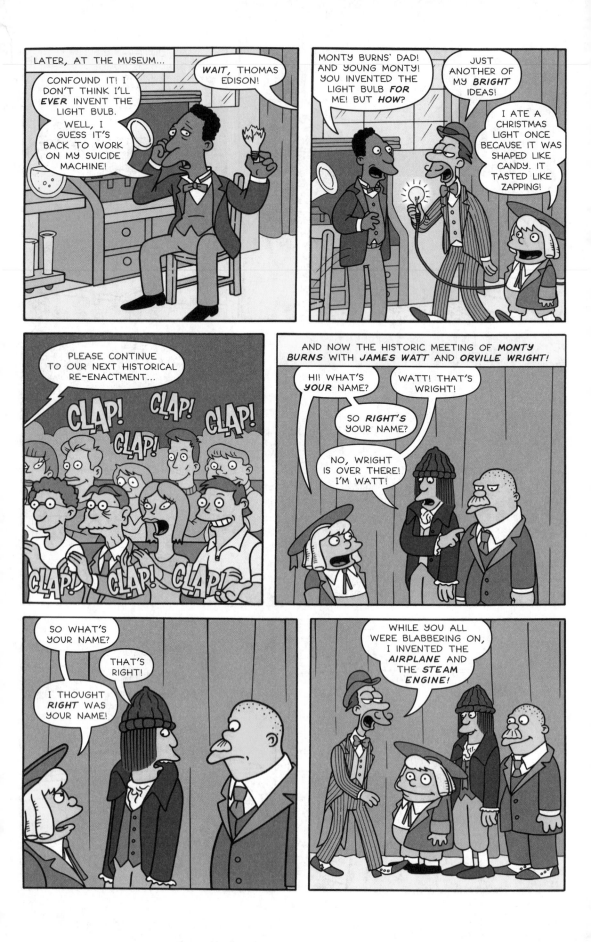

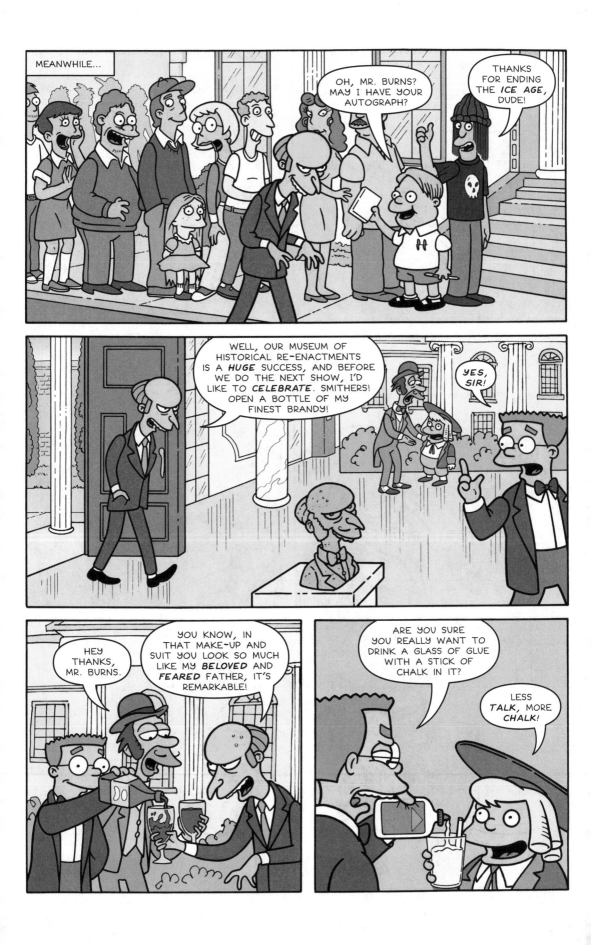

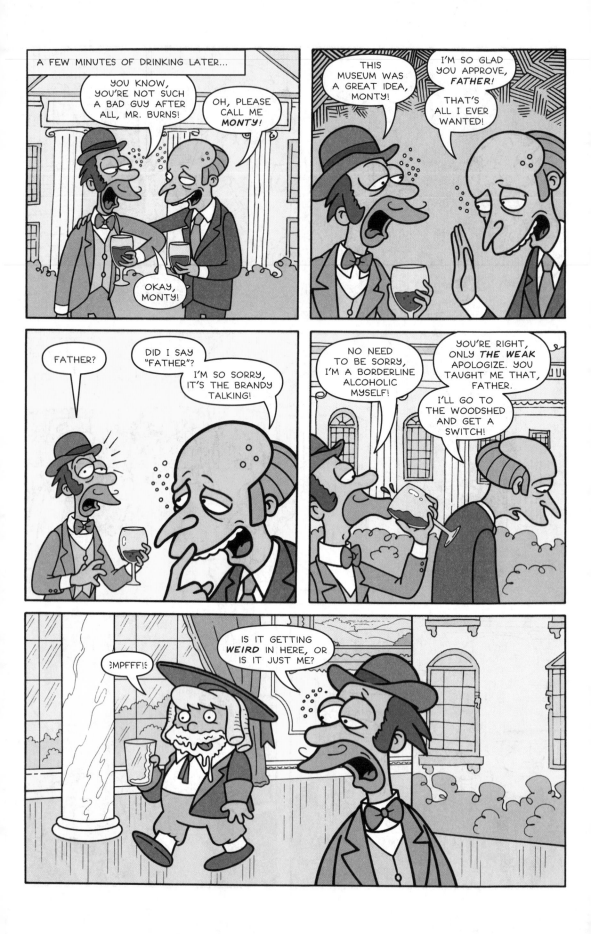

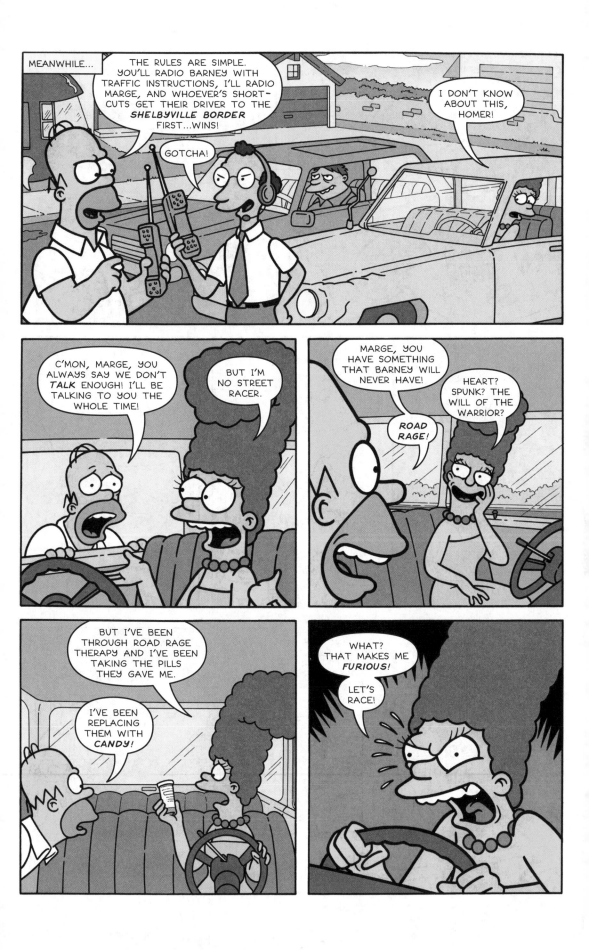

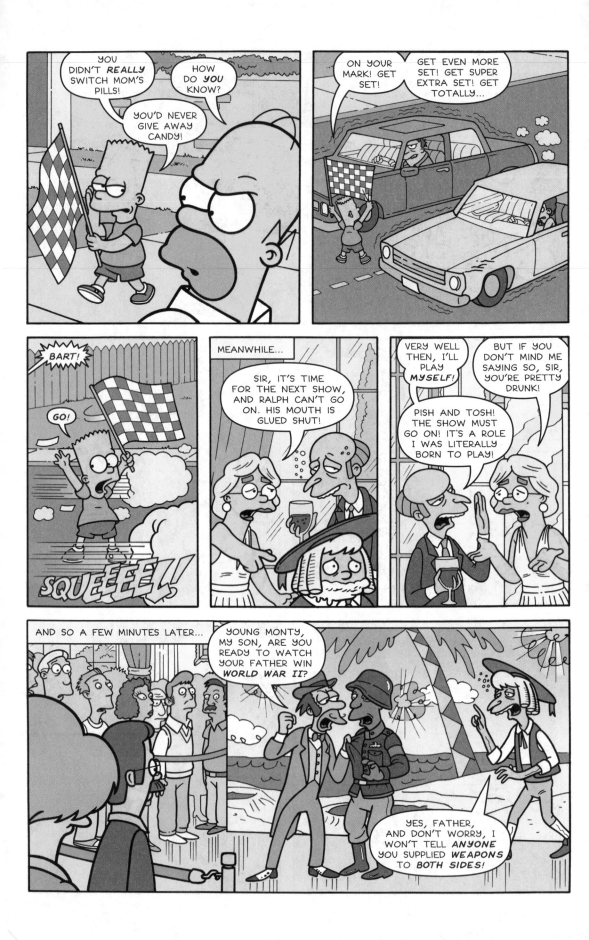

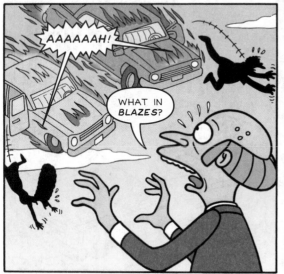

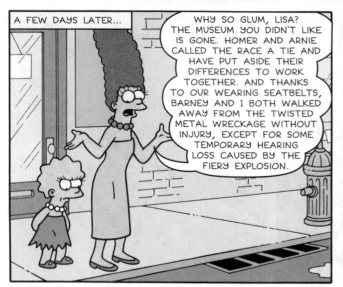

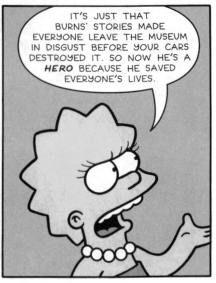

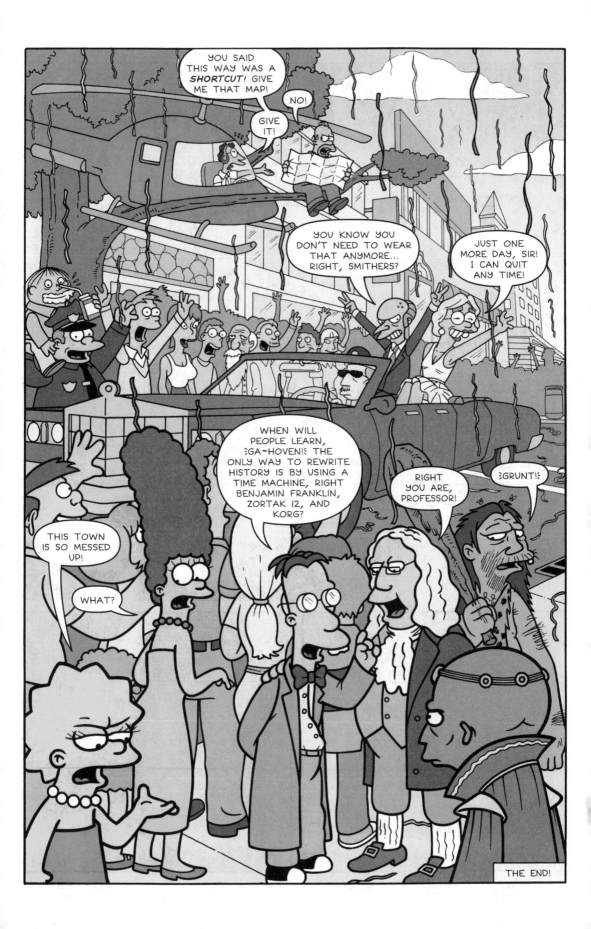

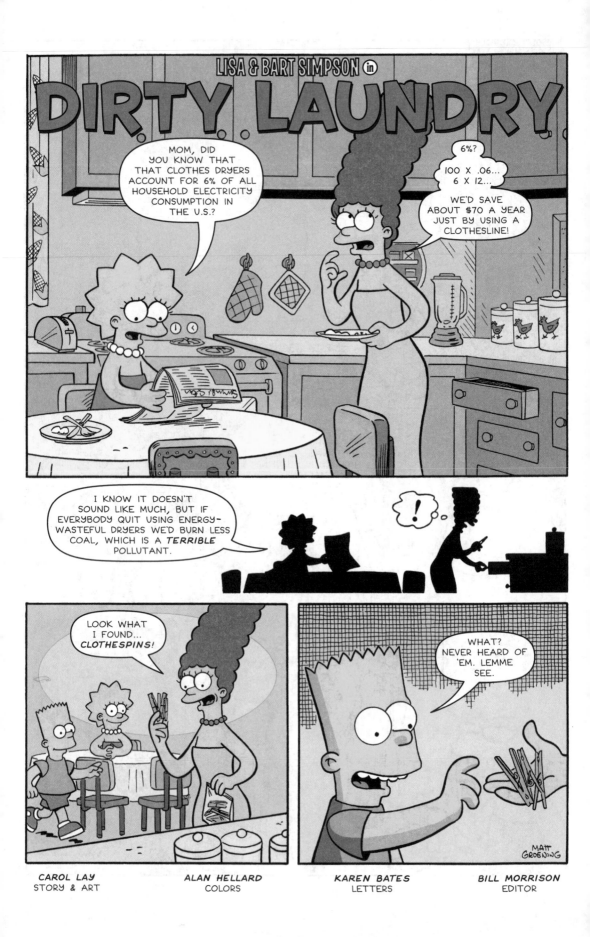

CAROL LAY
STORY & ART

ALAN HELLARD
COLORS

KAREN BATES
LETTERS

BILL MORRISON
EDITOR

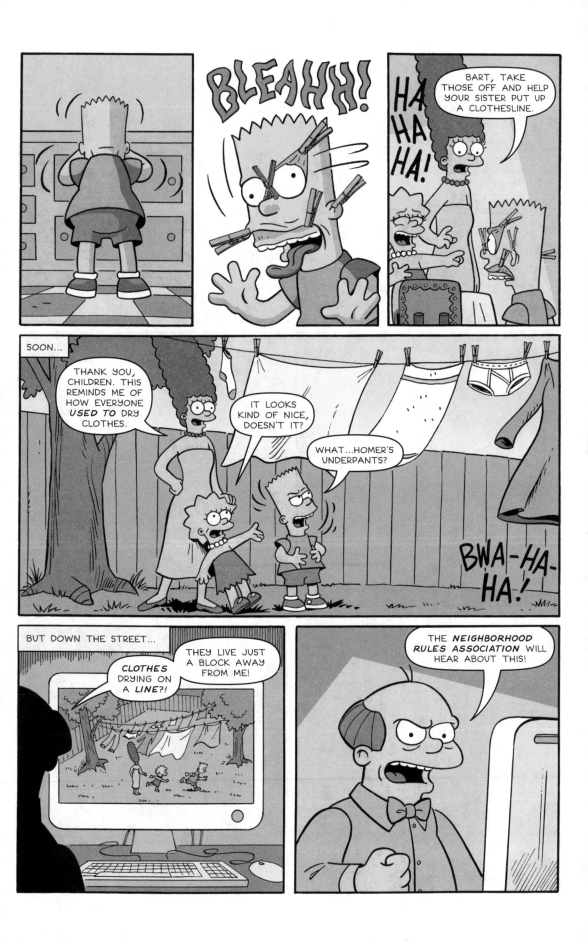

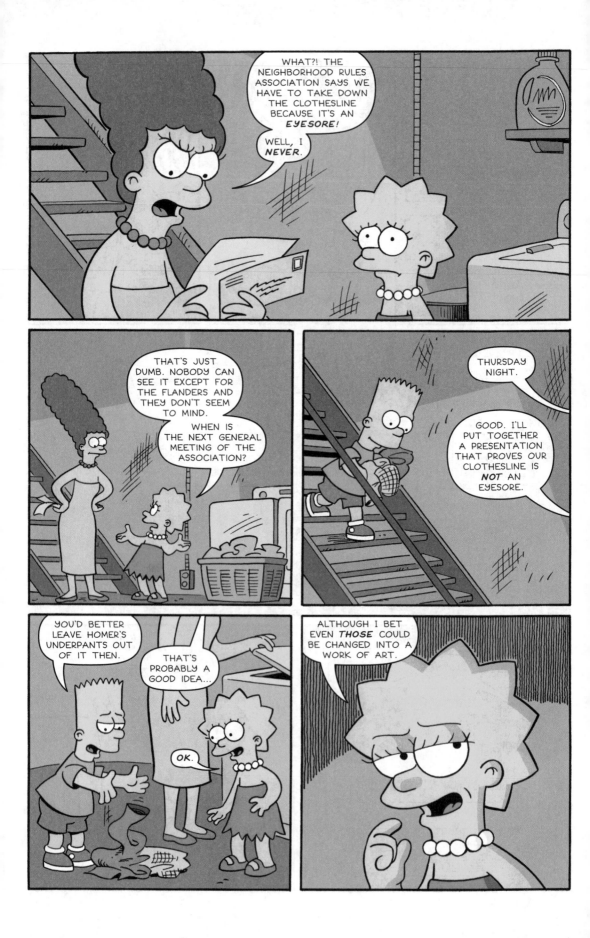

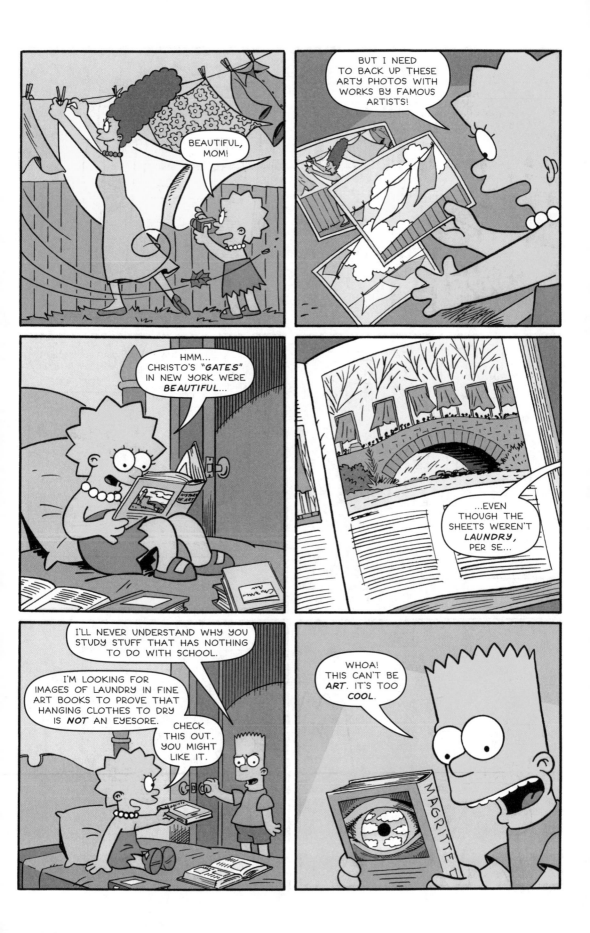

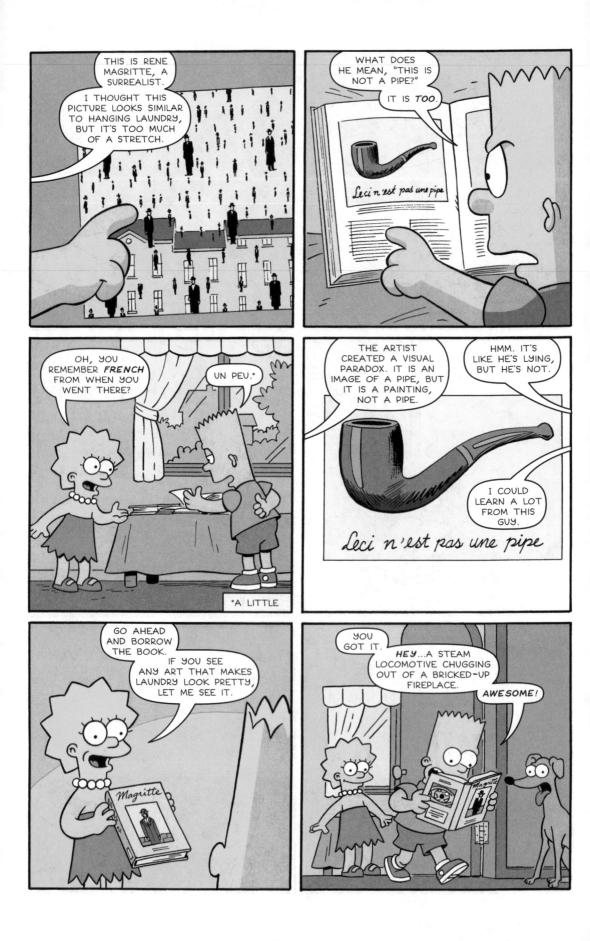

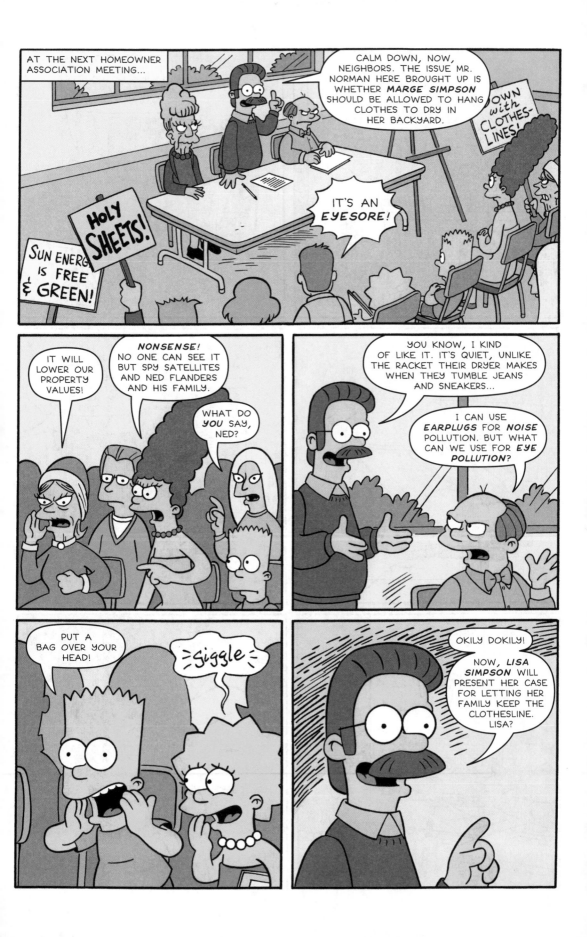

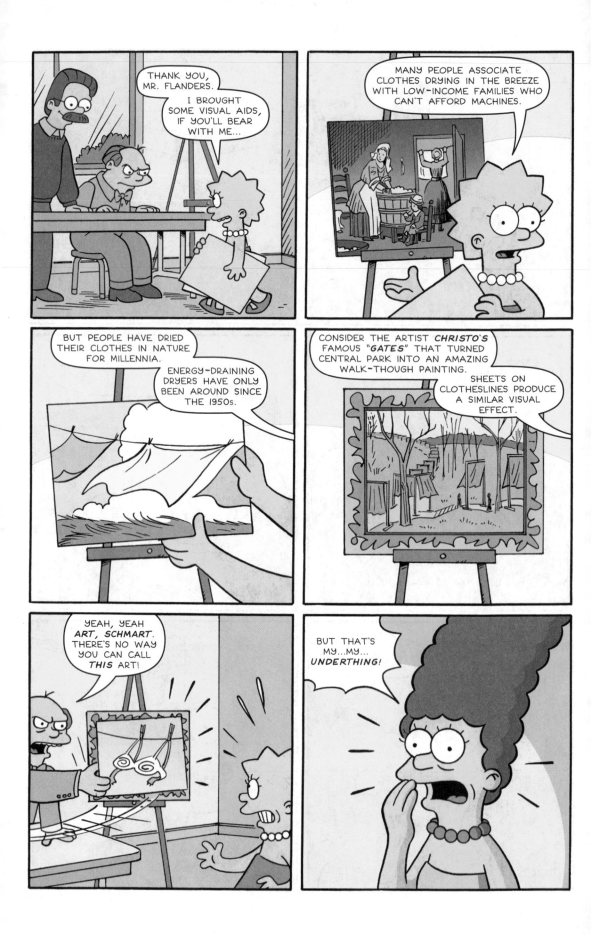

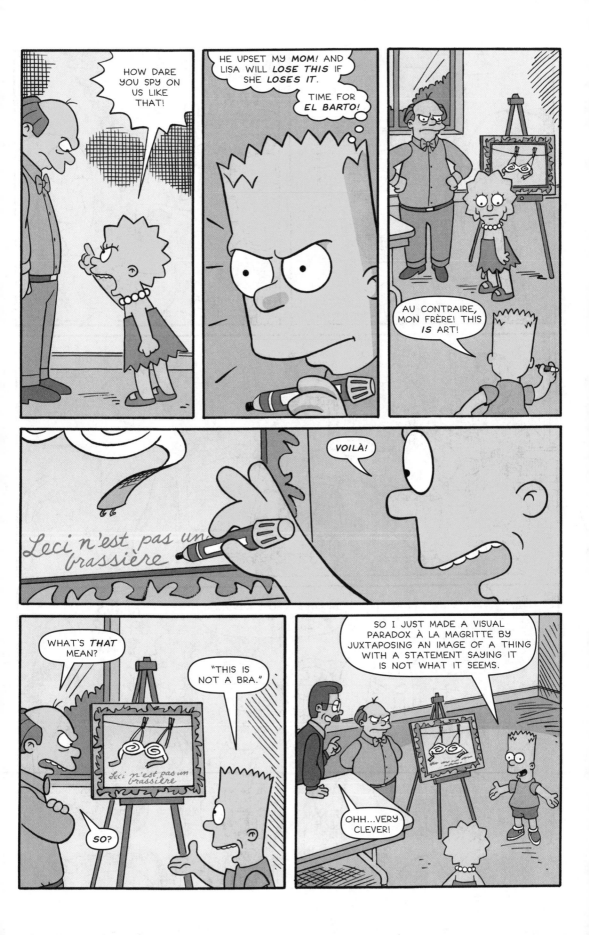

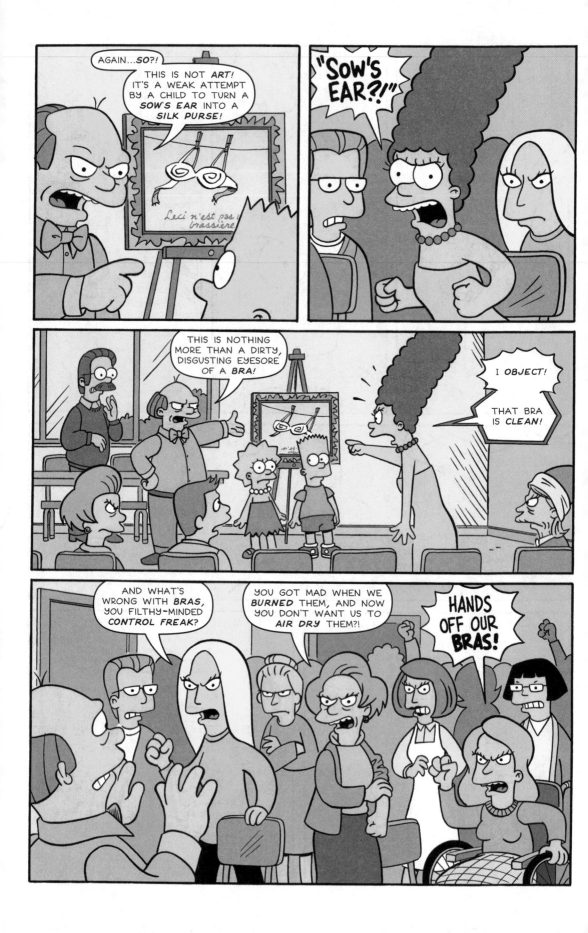

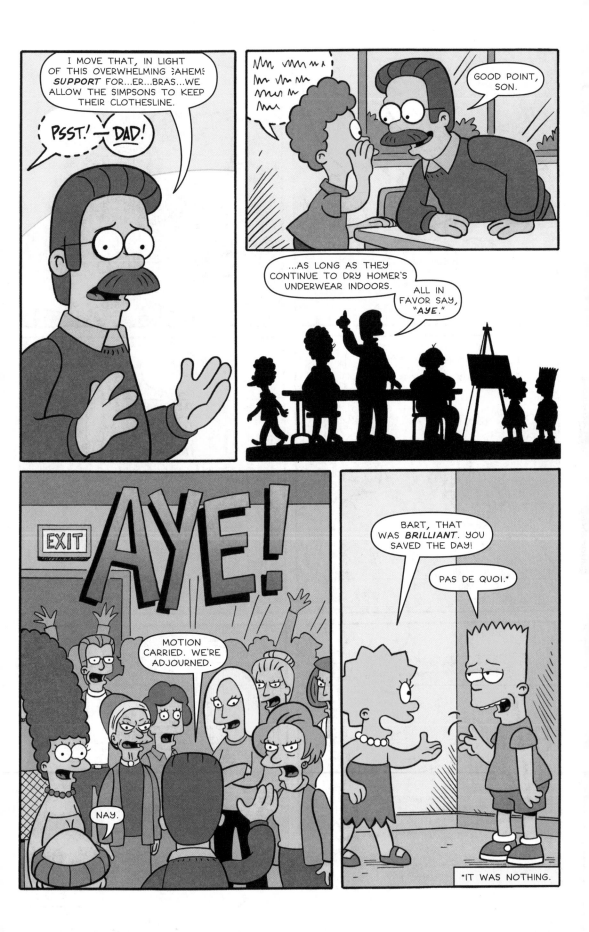

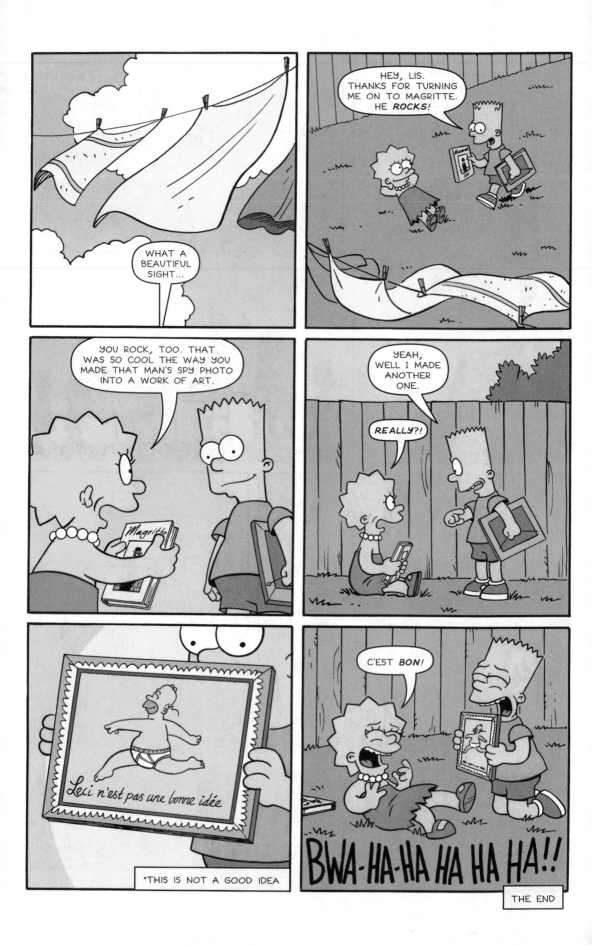

FUR 'N' HATE 451

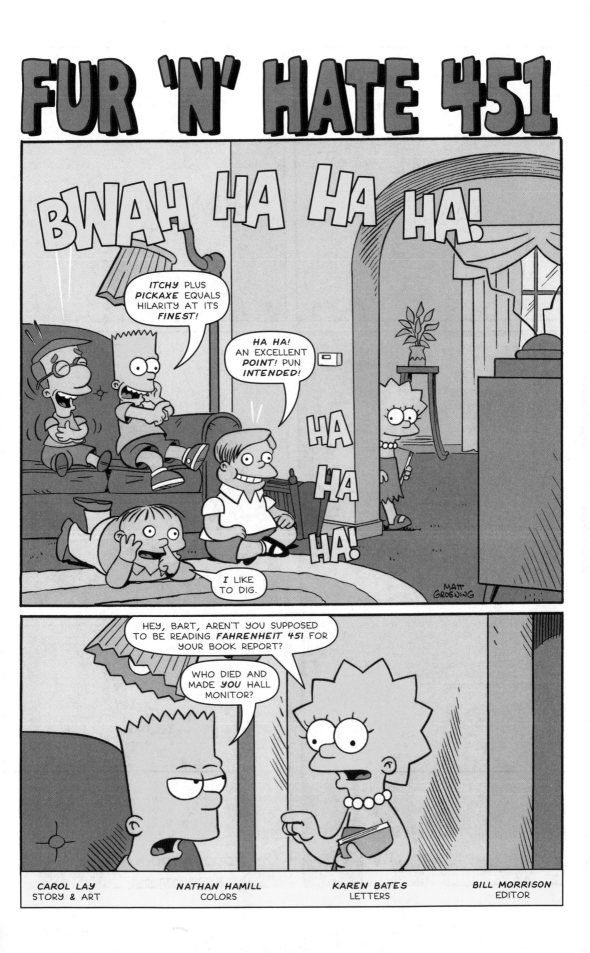

BWAH HA HA HA!

ITCHY plus PICKAXE EQUALS HILARITY AT ITS FINEST!

HA HA! AN EXCELLENT POINT! PUN INTENDED!

HA HA HA!

I LIKE TO DIG.

HEY, BART, AREN'T YOU SUPPOSED TO BE READING FAHRENHEIT 451 FOR YOUR BOOK REPORT?

WHO DIED AND MADE YOU HALL MONITOR?

CAROL LAY
STORY & ART

NATHAN HAMILL
COLORS

KAREN BATES
LETTERS

BILL MORRISON
EDITOR

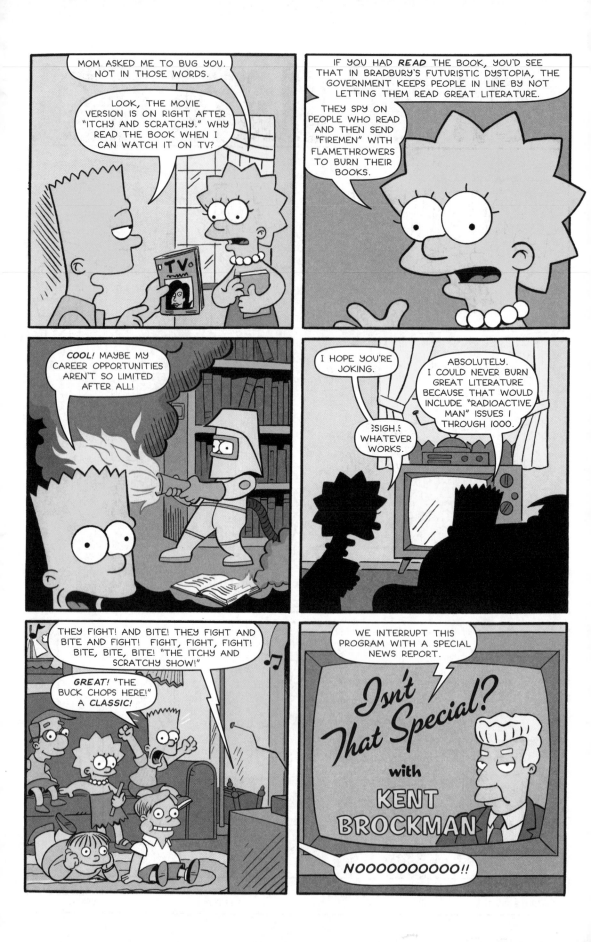

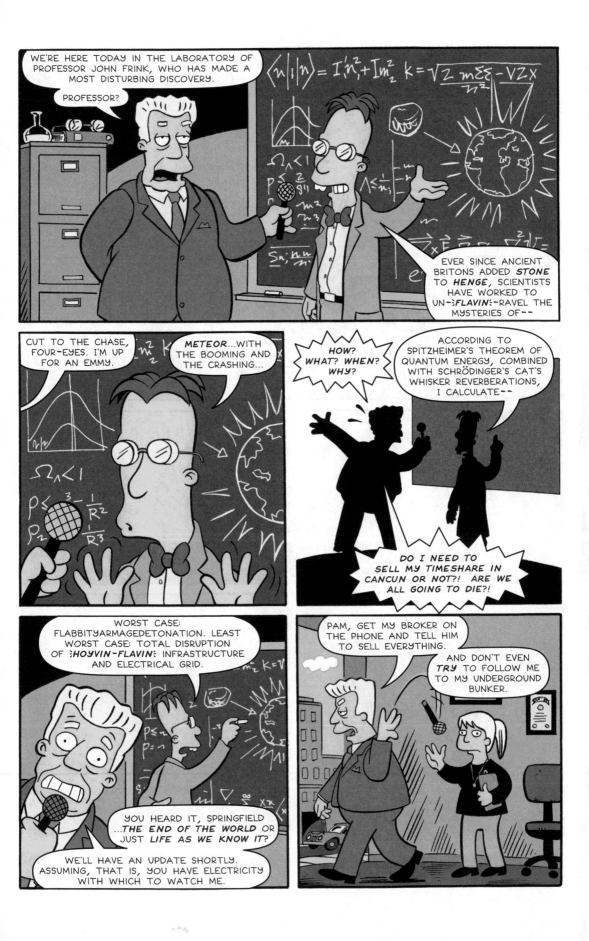

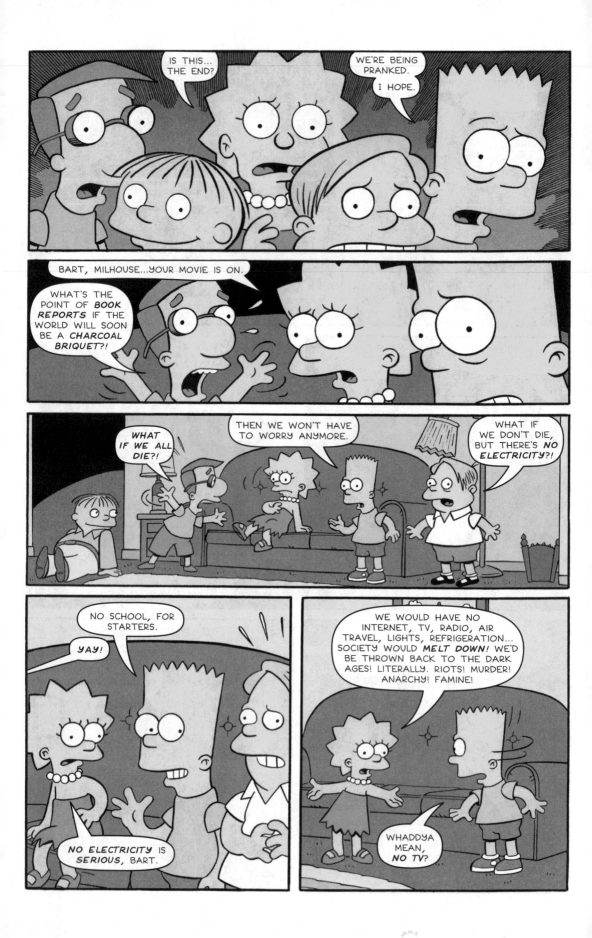

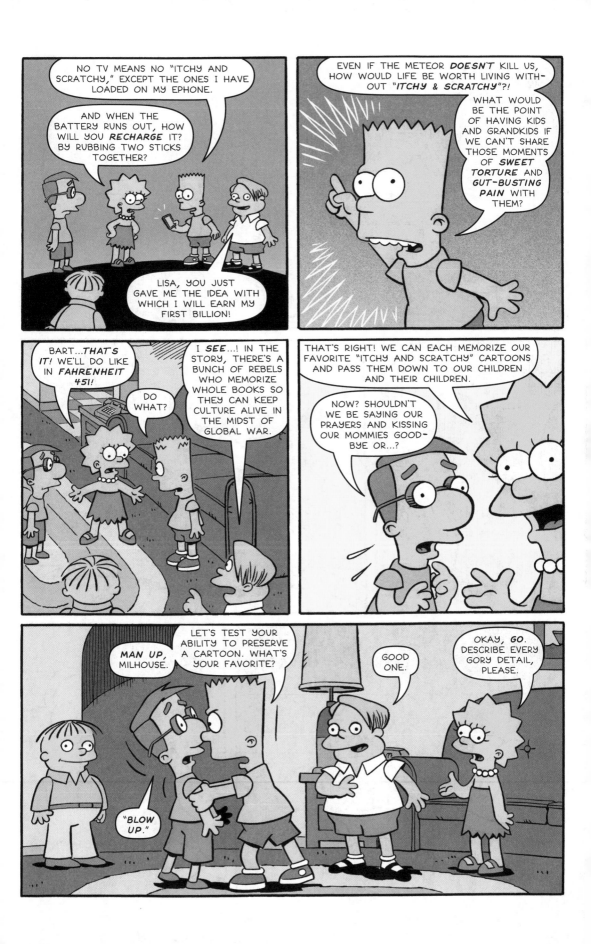

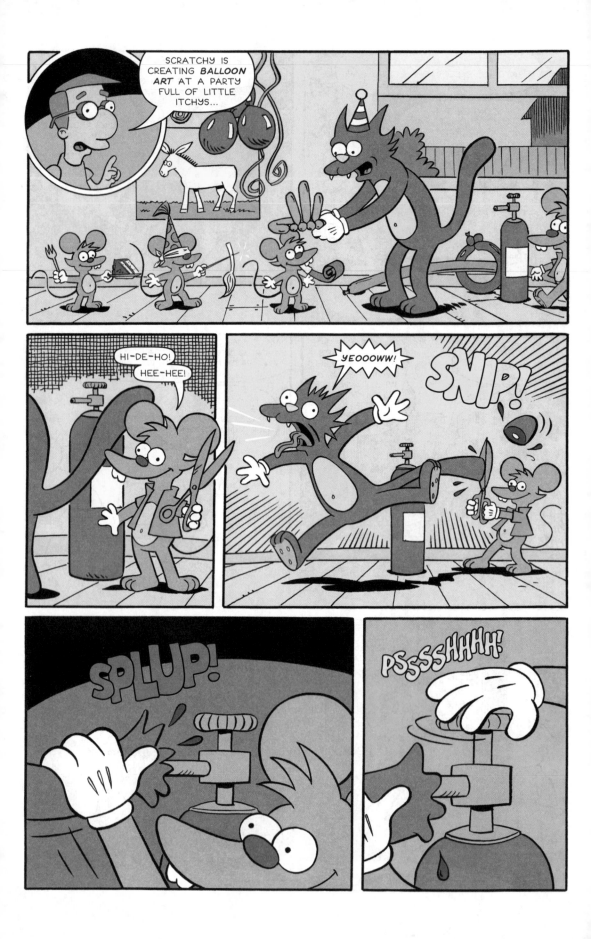

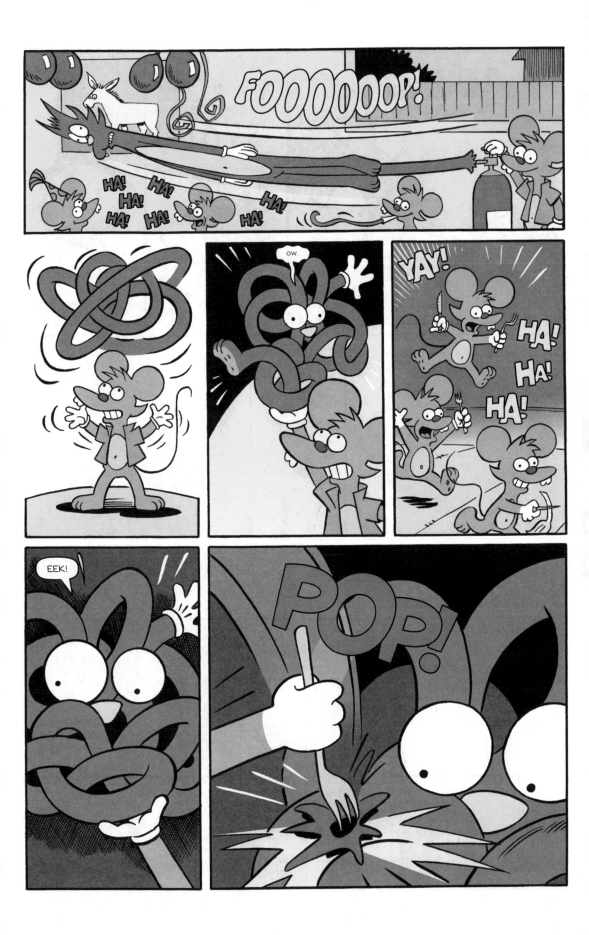

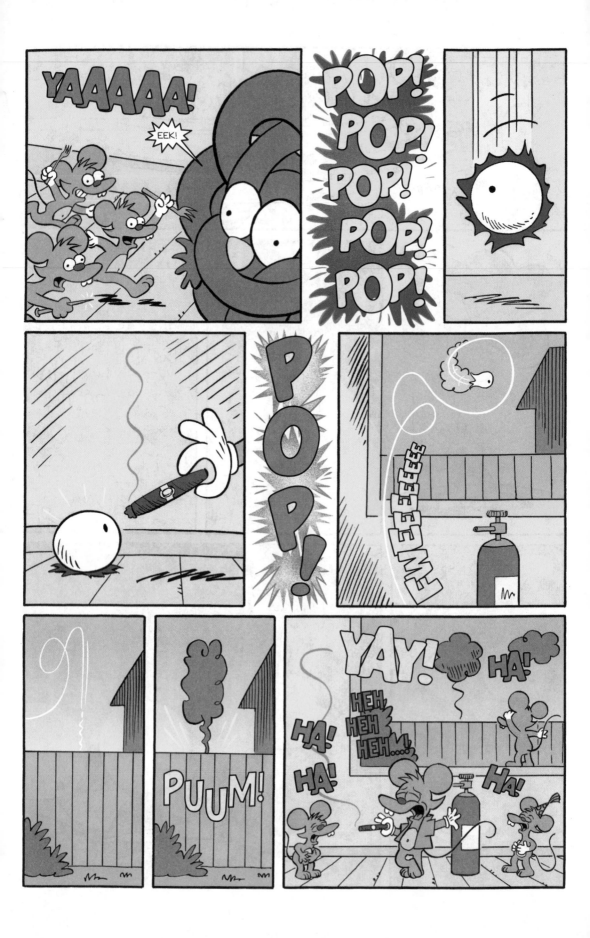

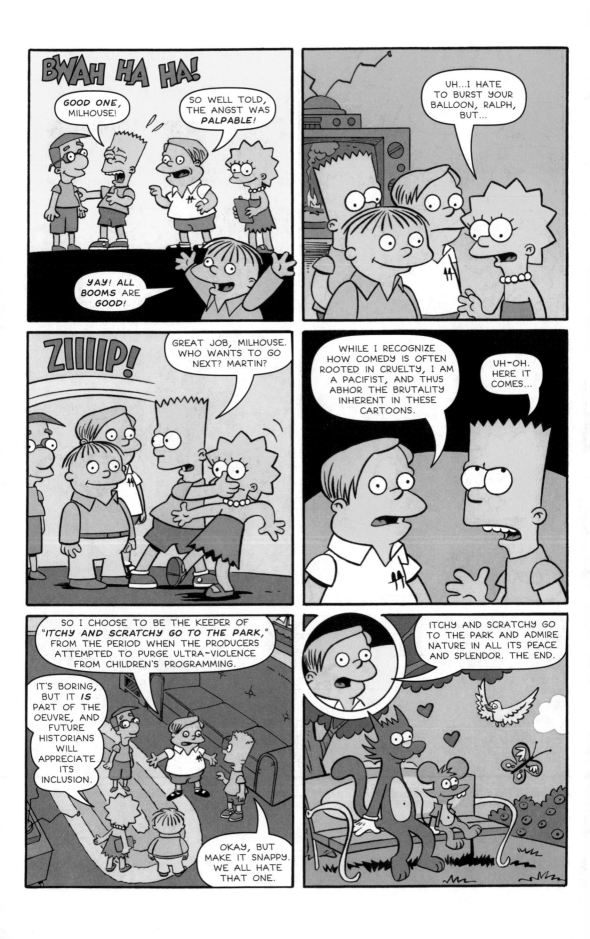

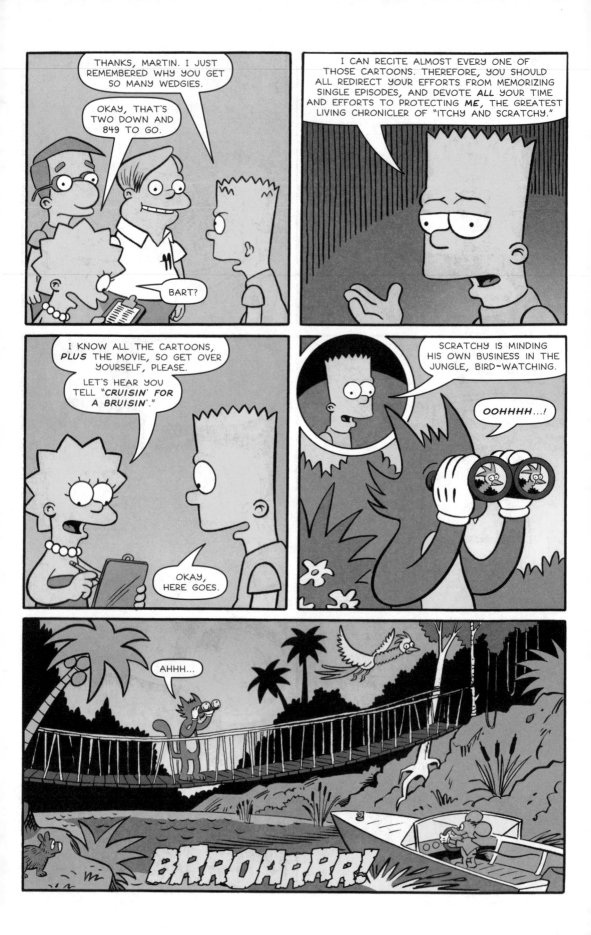

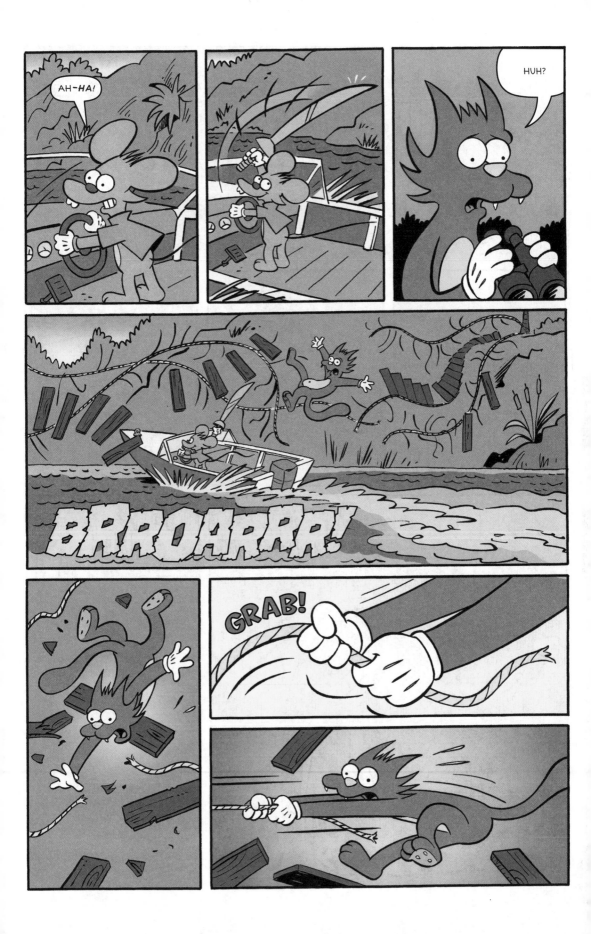

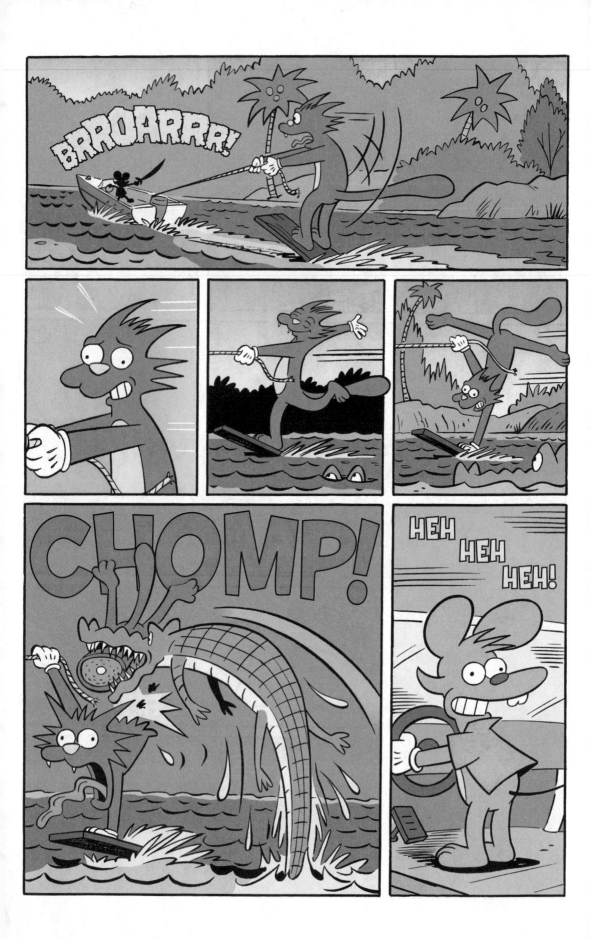

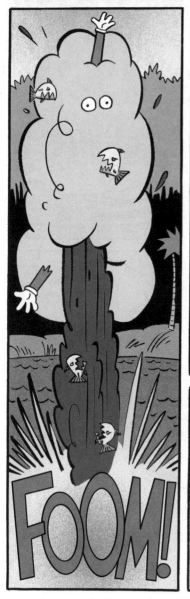
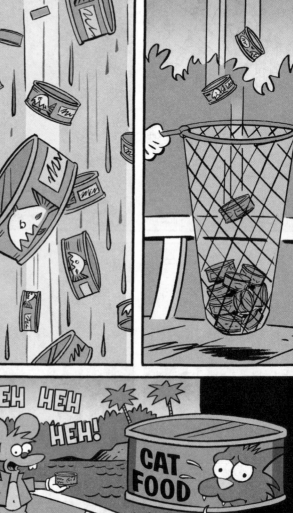

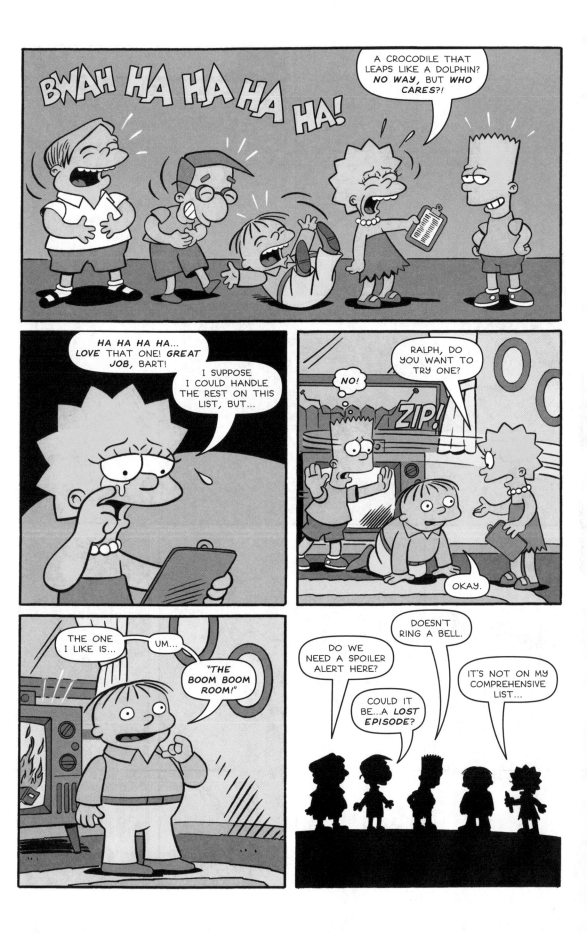

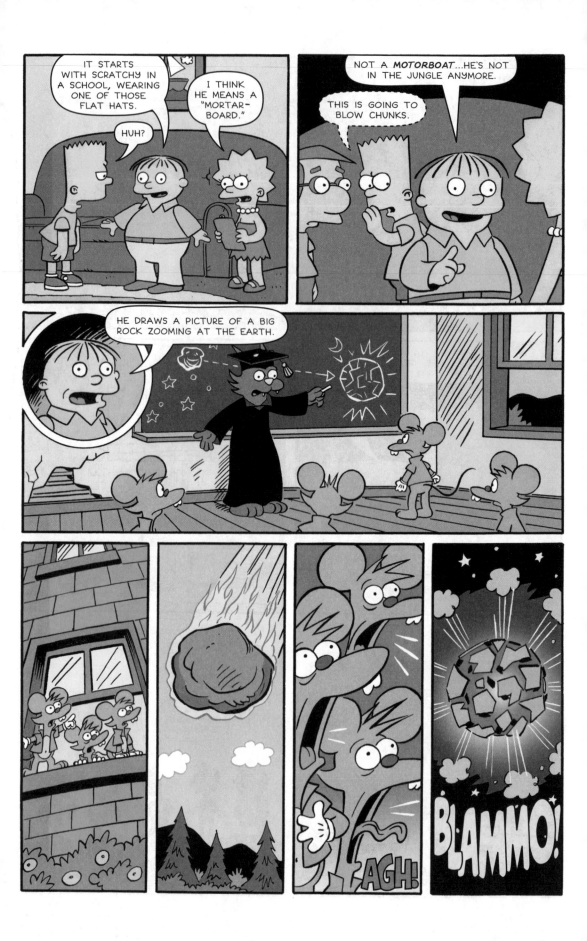

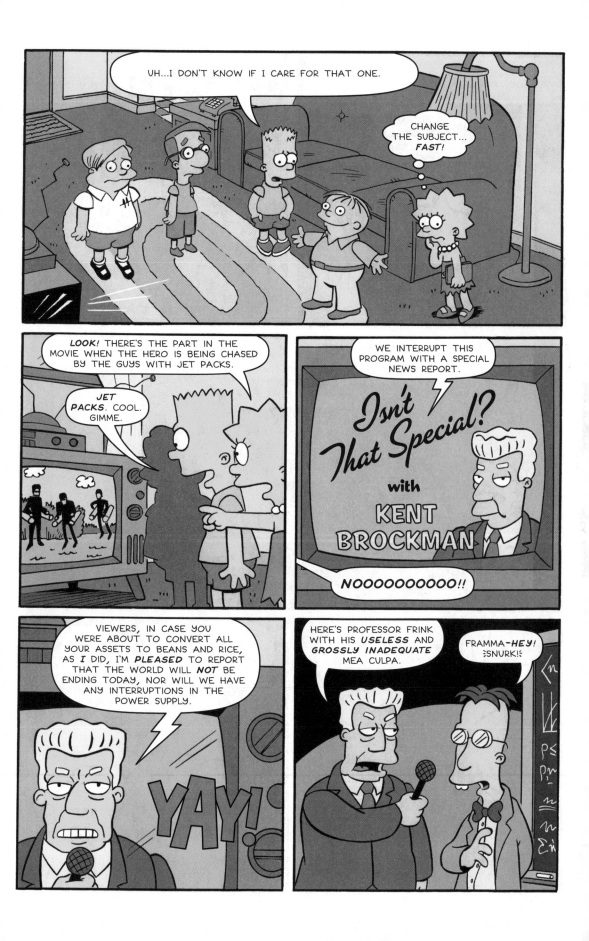

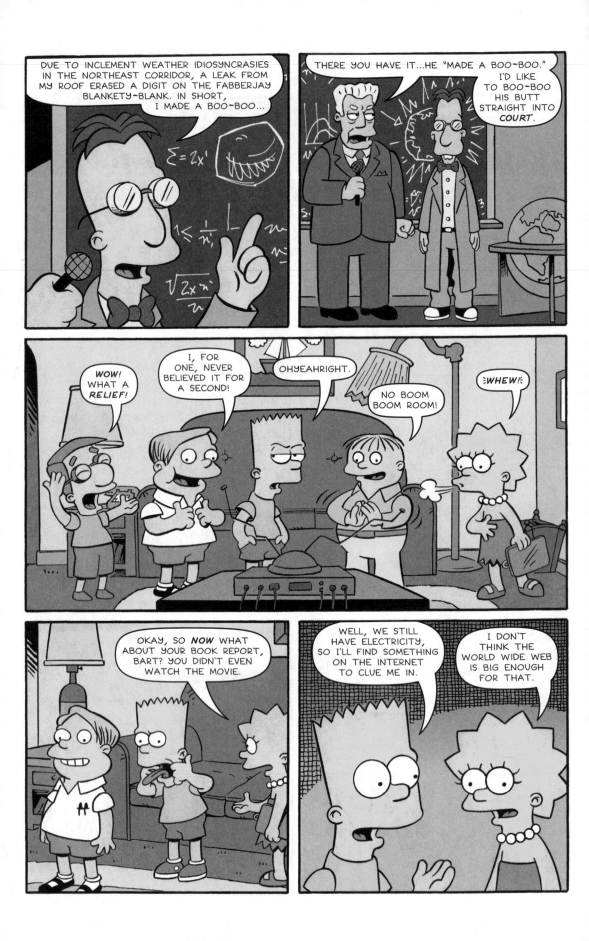

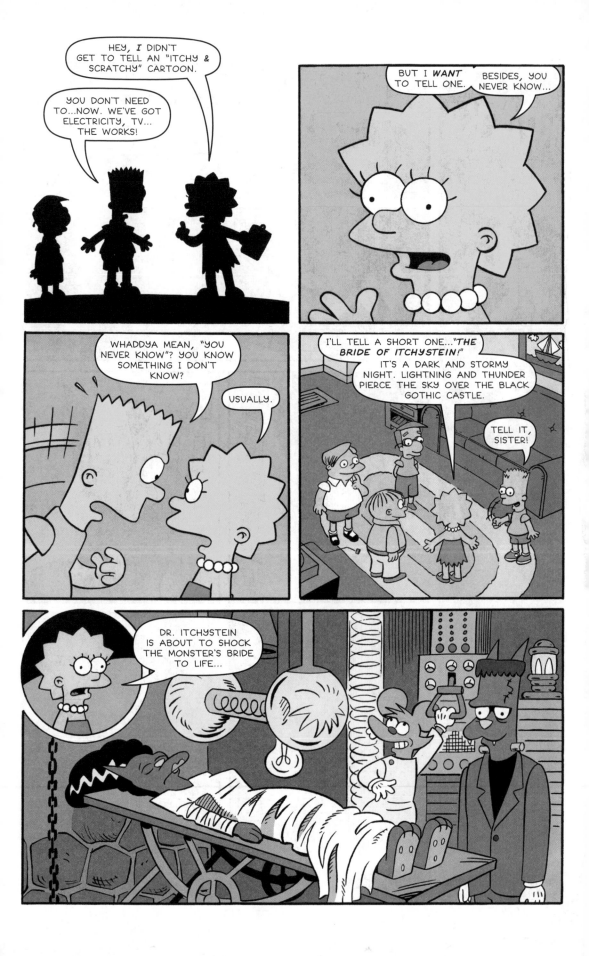

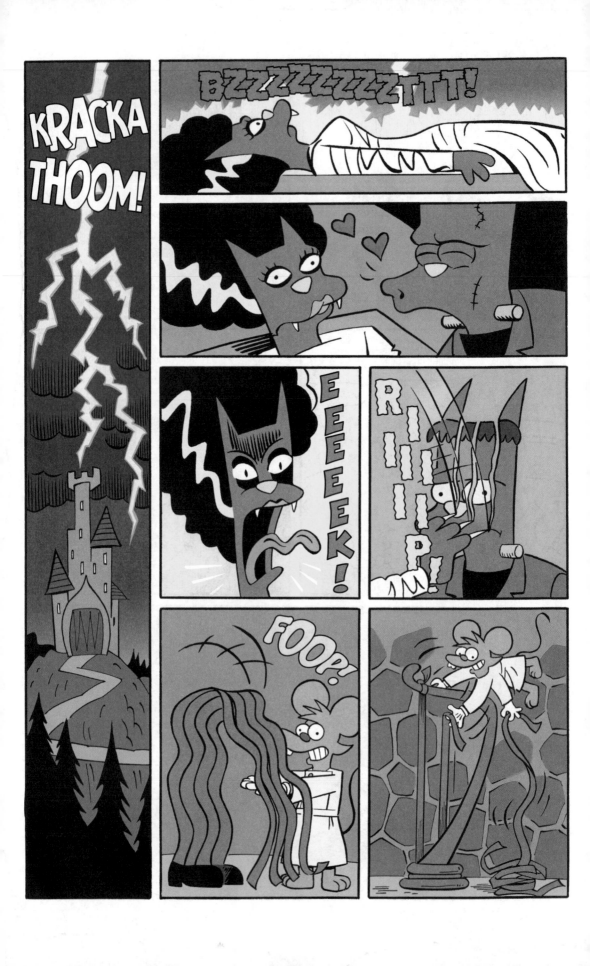

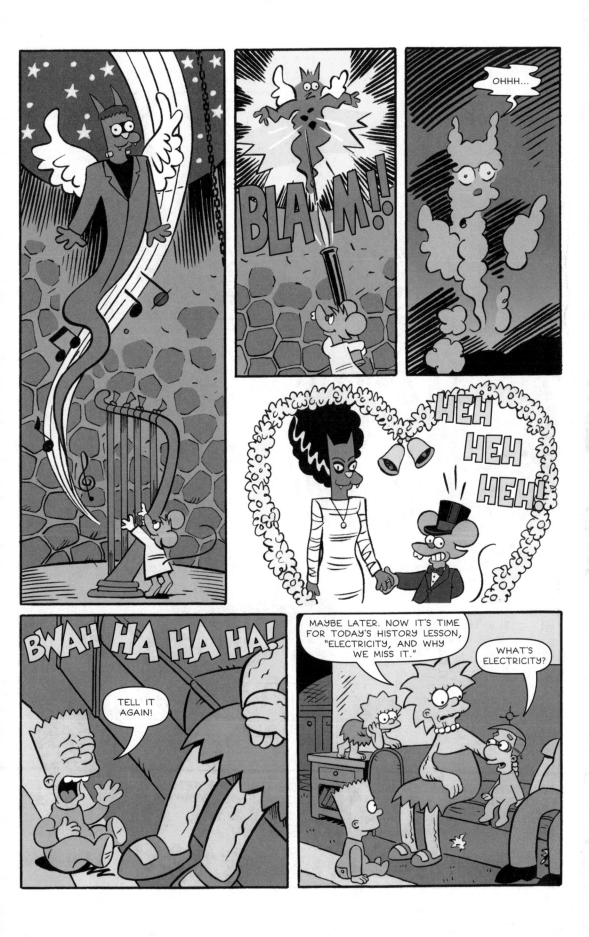

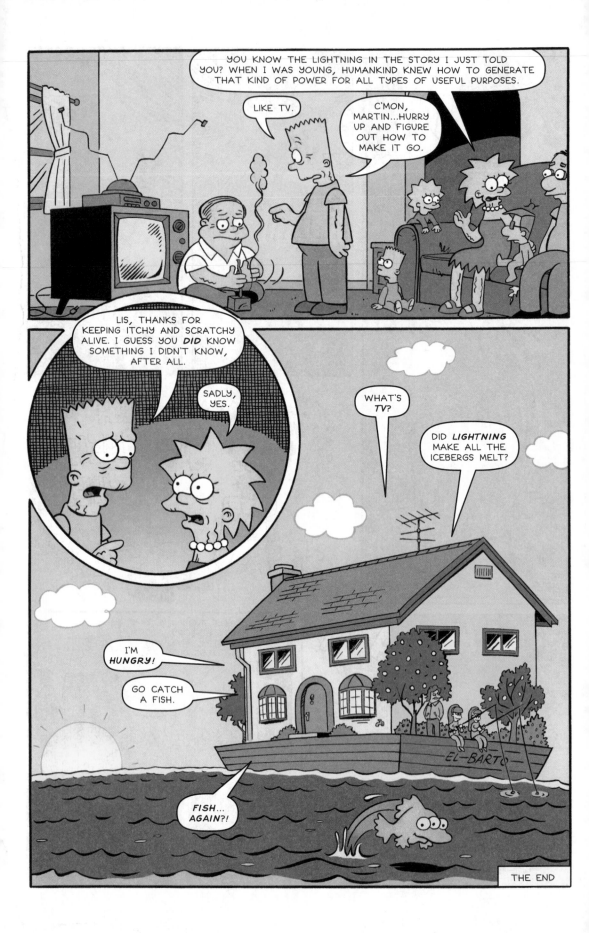

THE END

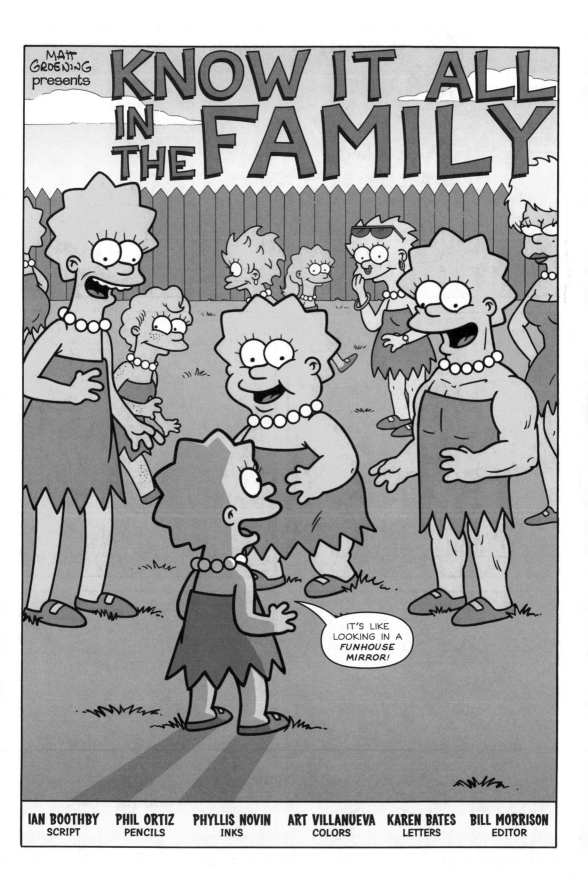

IAN BOOTHBY
SCRIPT

PHIL ORTIZ
PENCILS

PHYLLIS NOVIN
INKS

ART VILLANUEVA
COLORS

KAREN BATES
LETTERS

BILL MORRISON
EDITOR

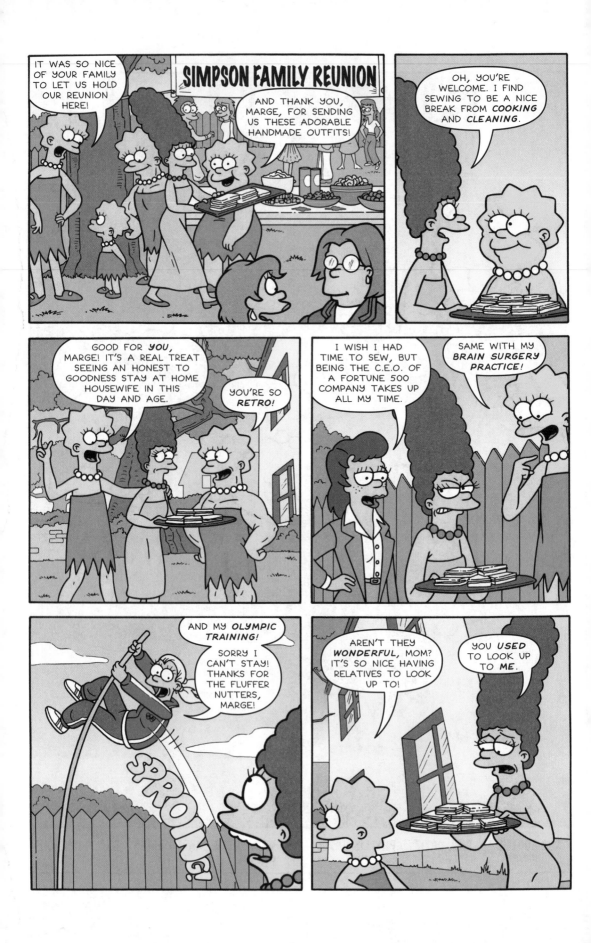

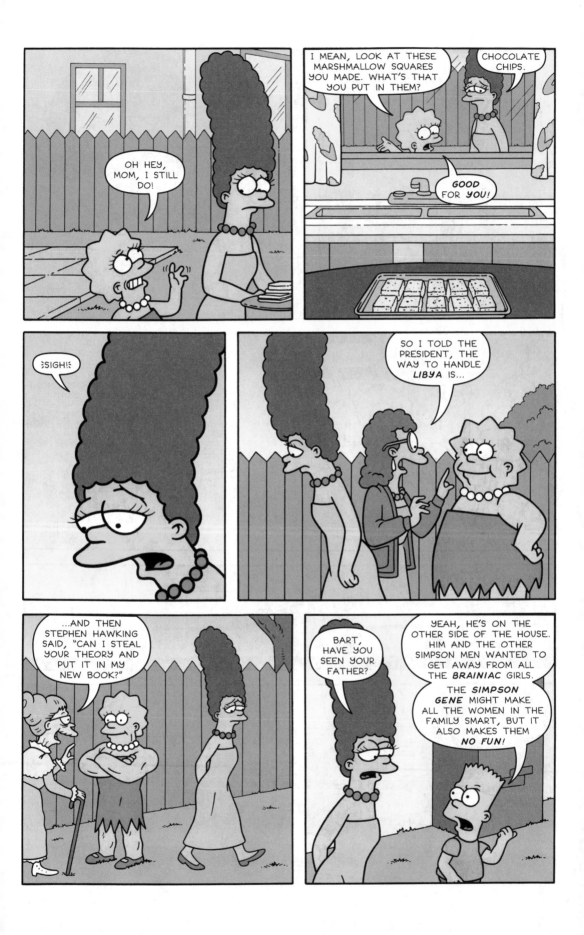

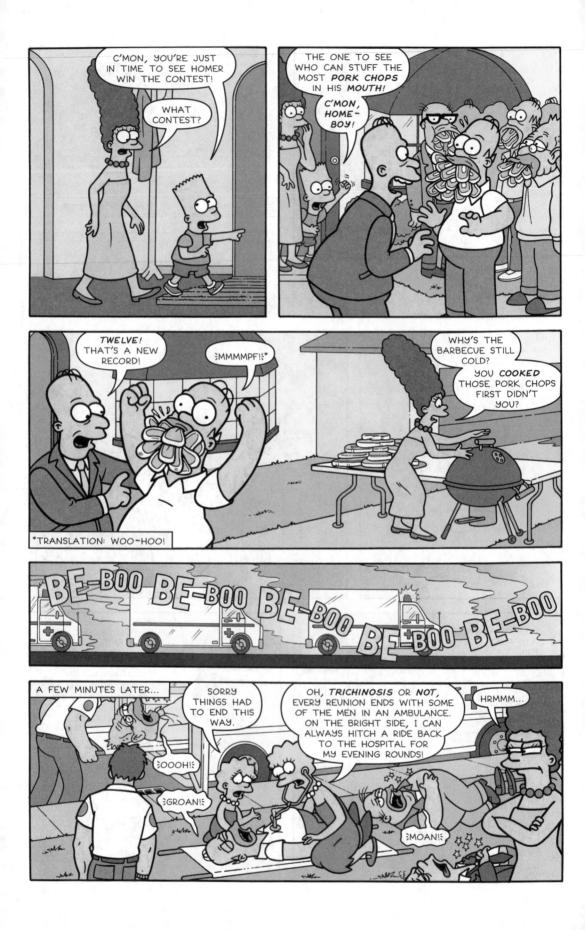

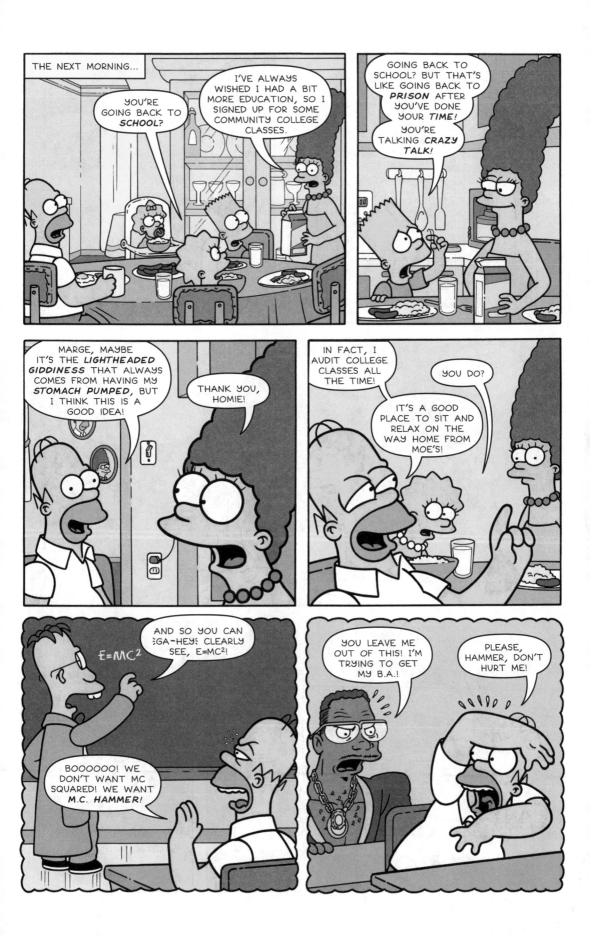

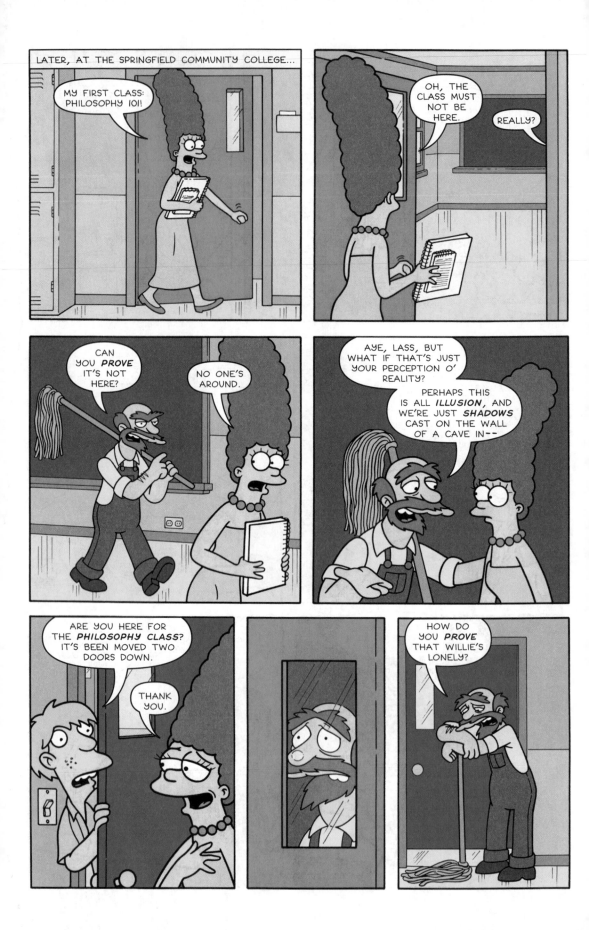

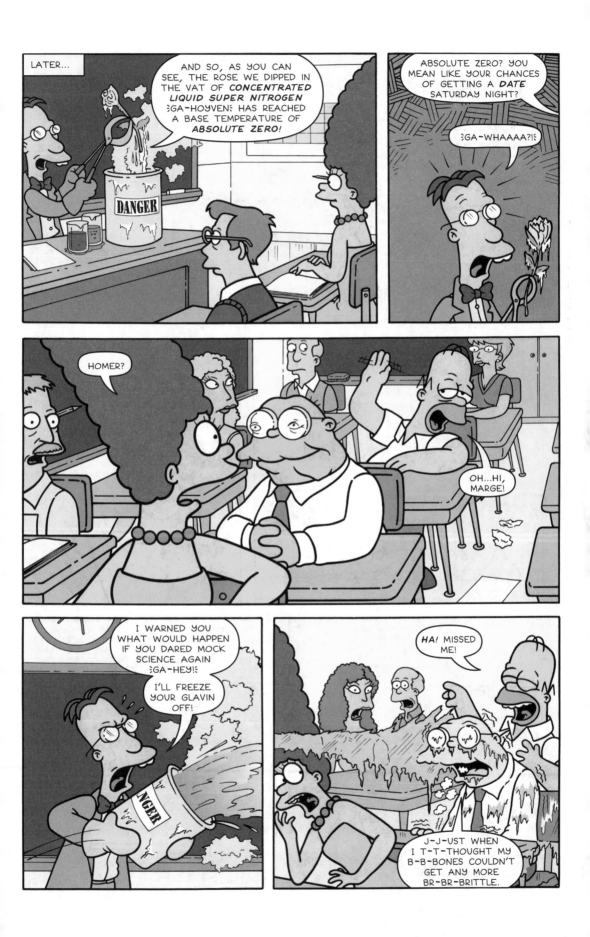

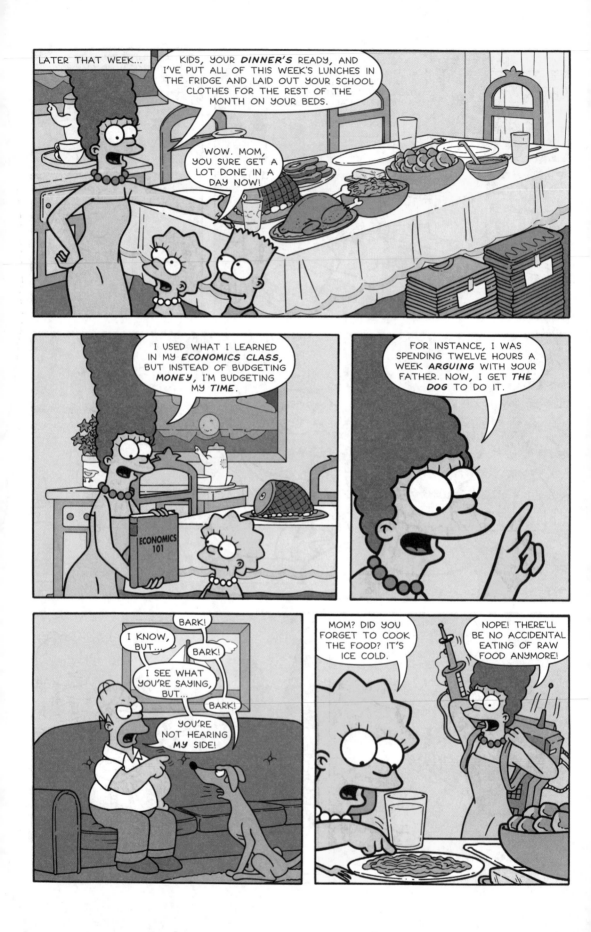

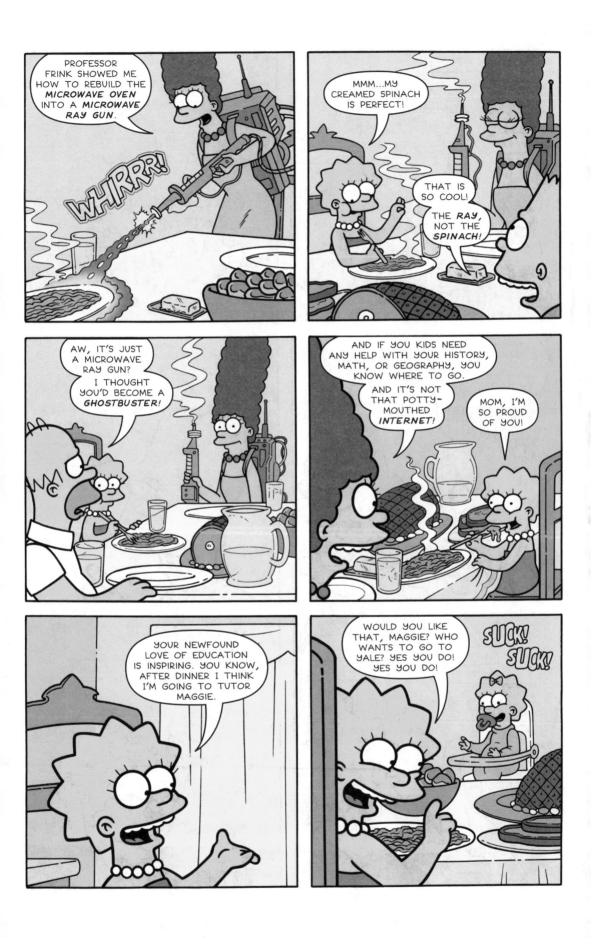

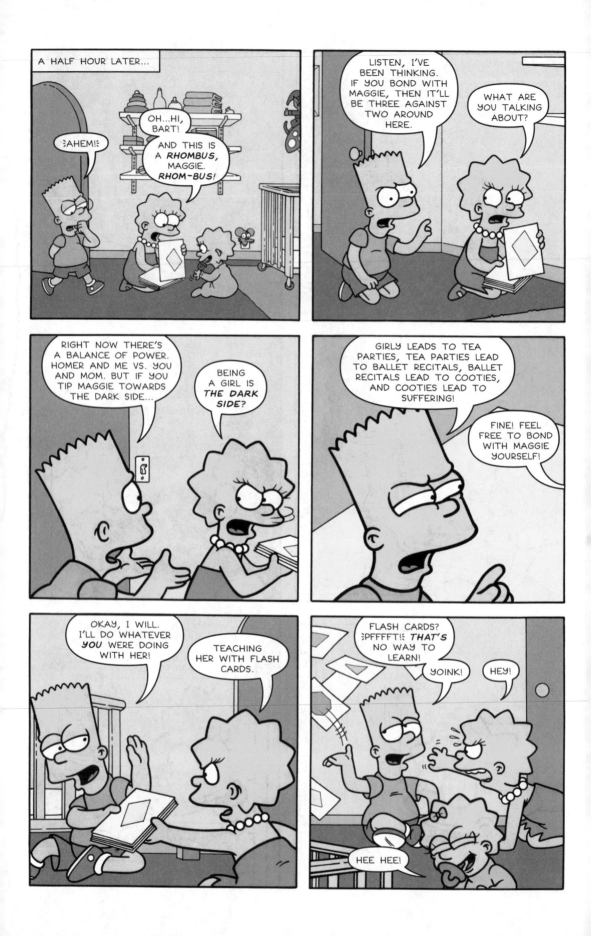

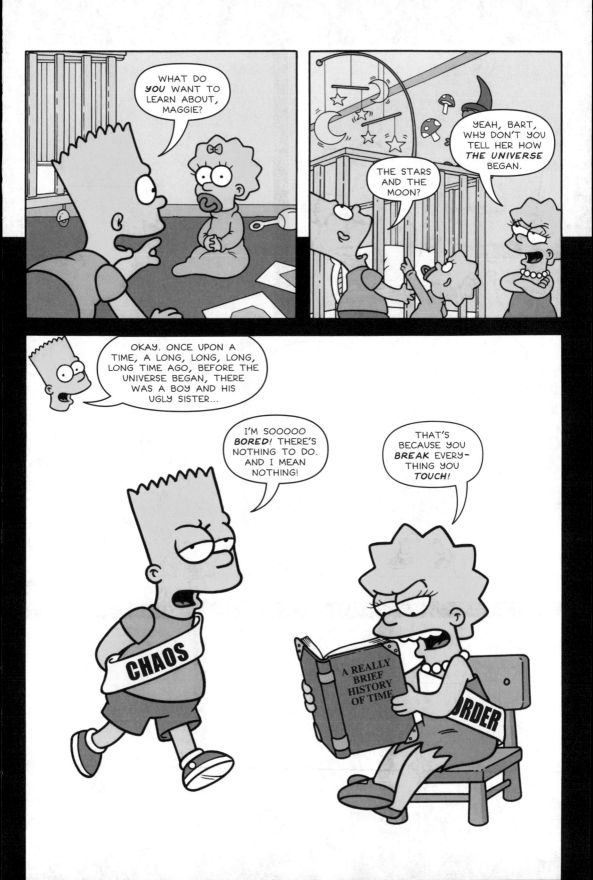

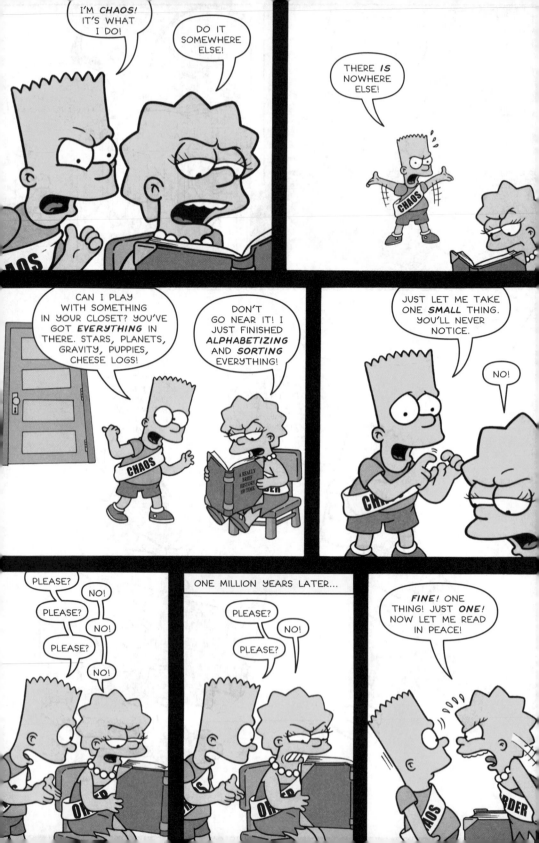

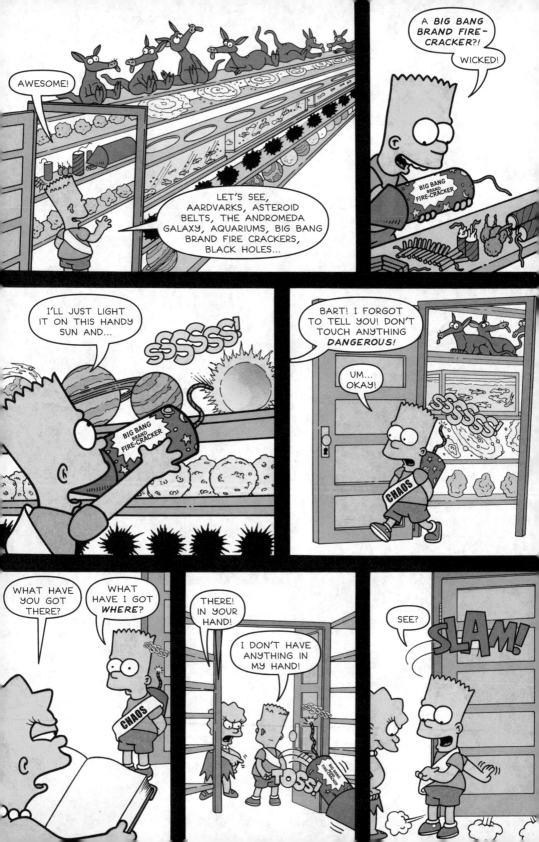

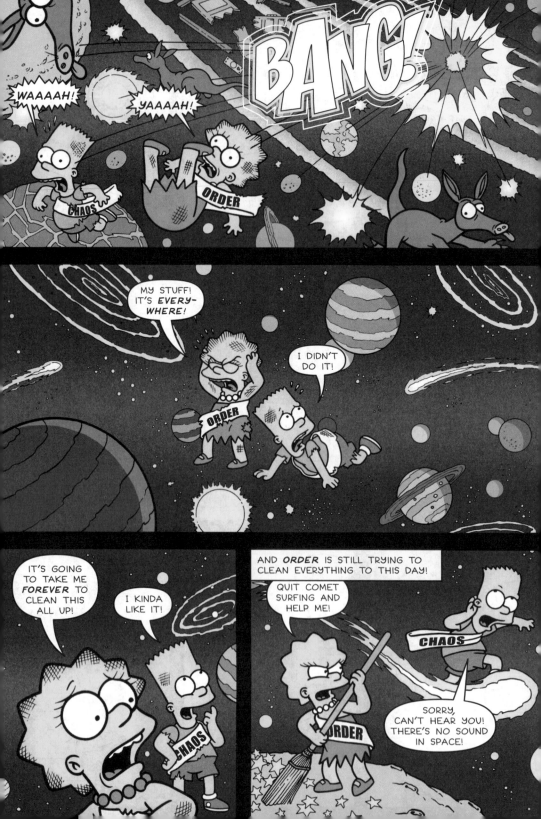

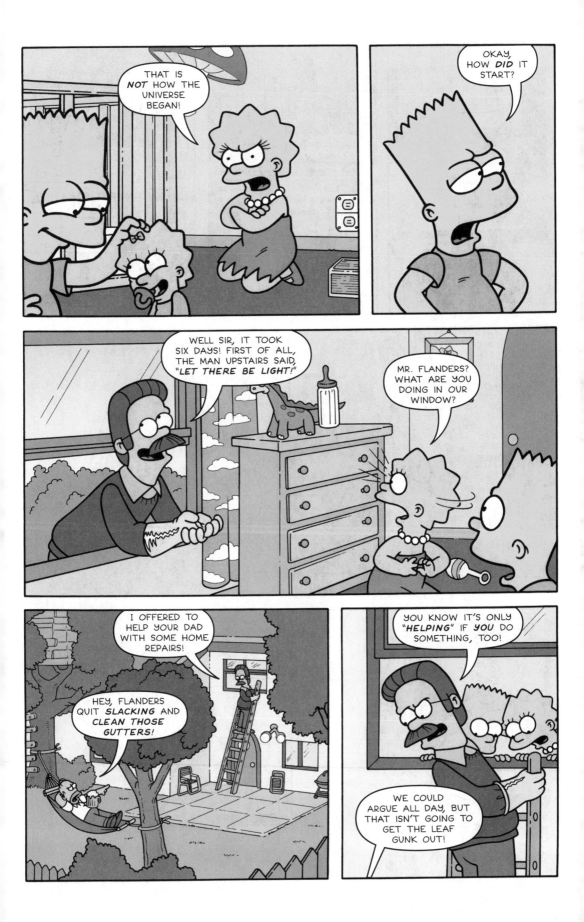

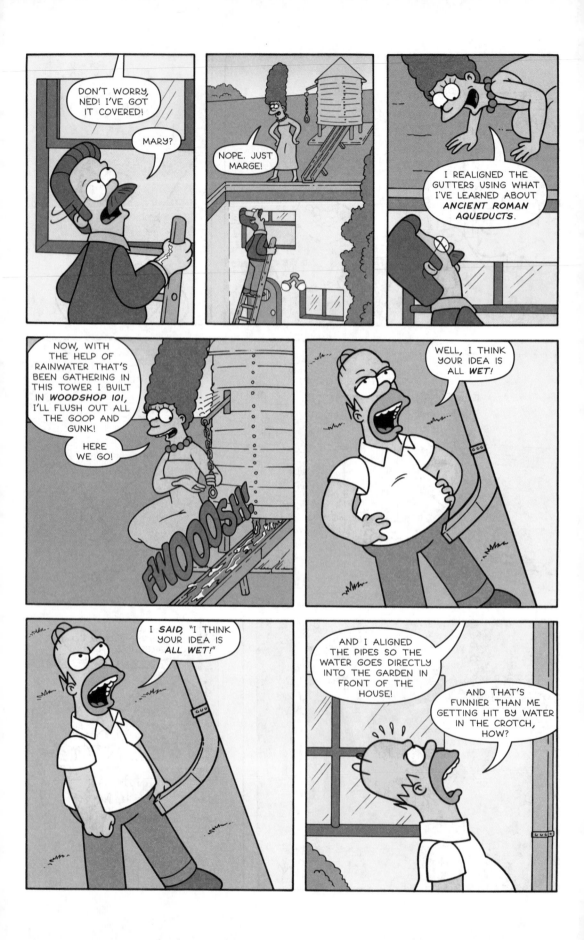

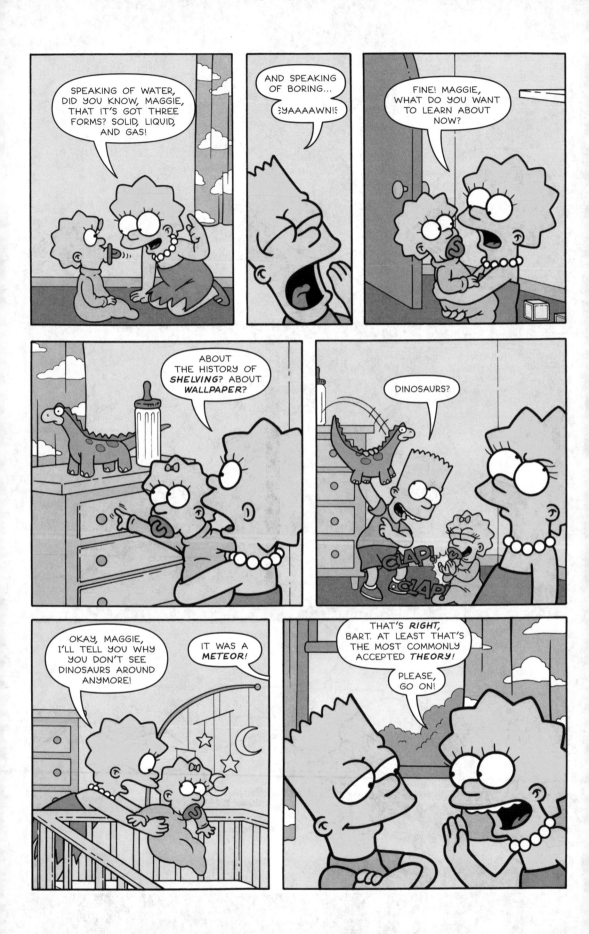

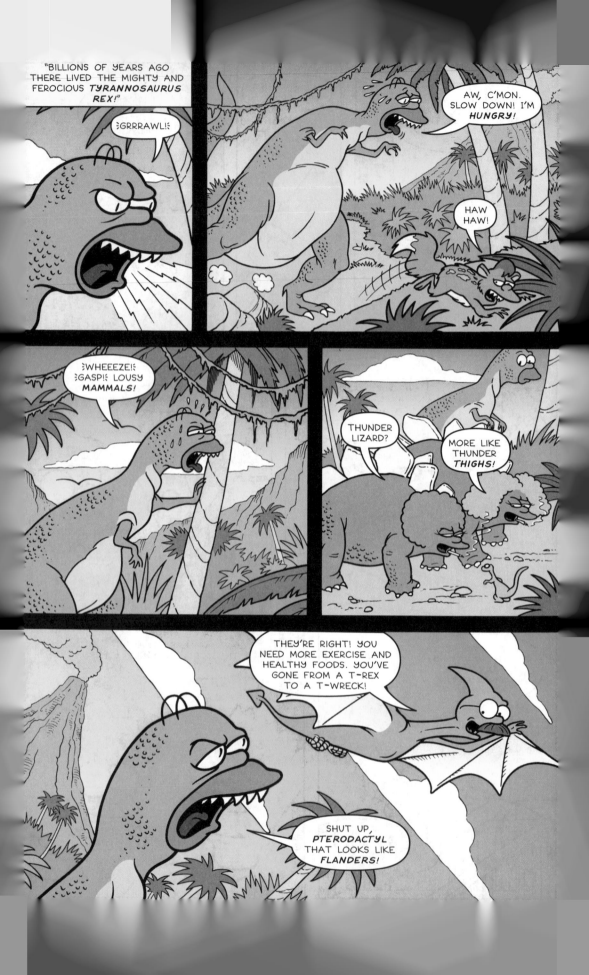

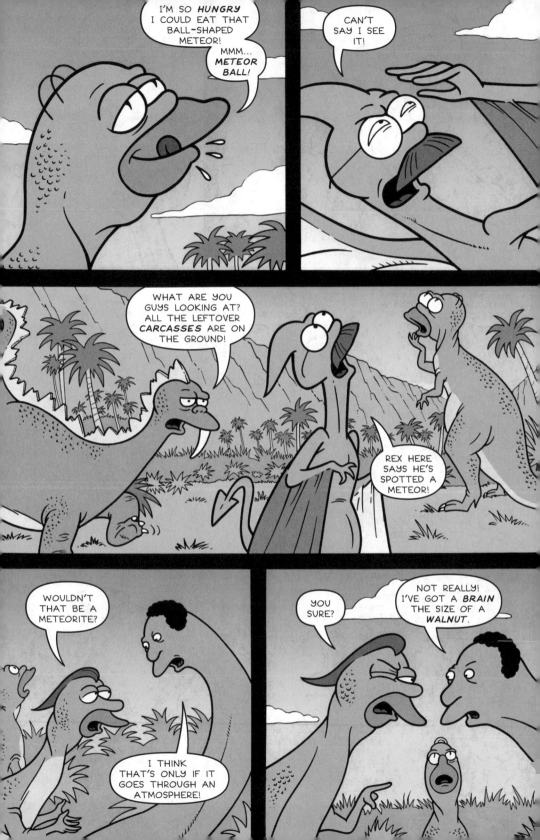

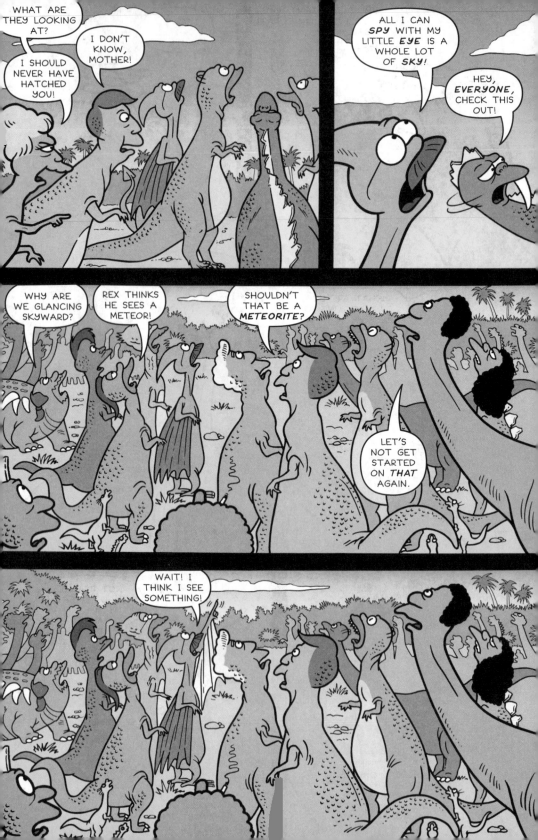

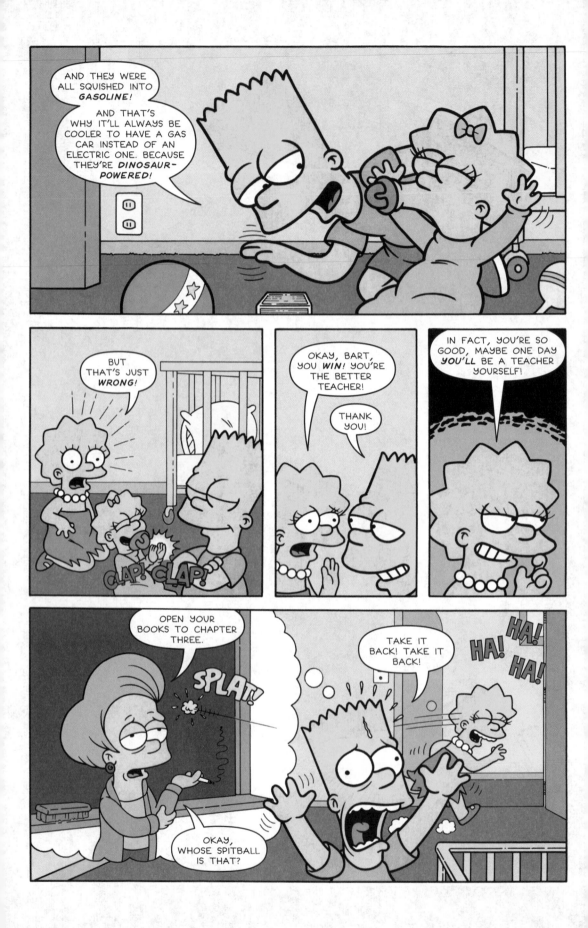

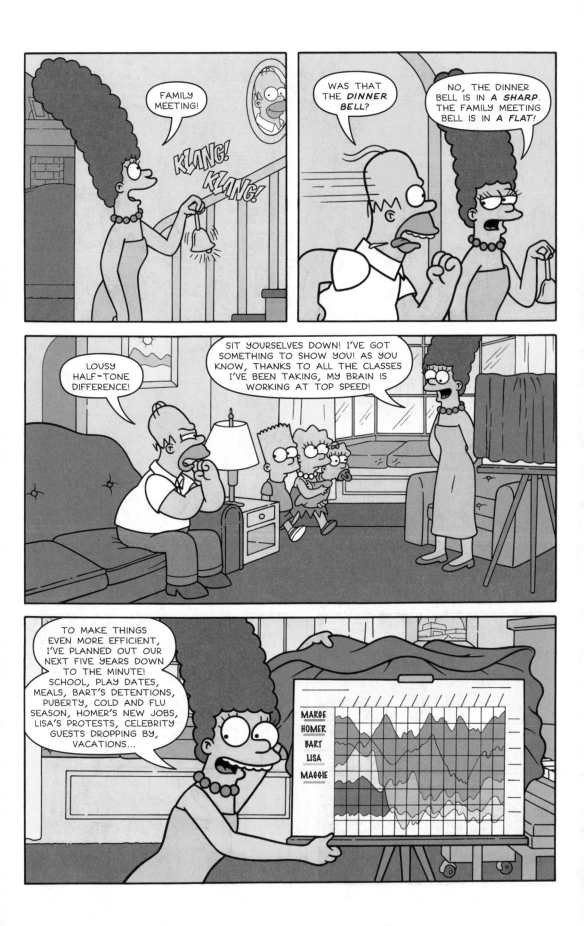

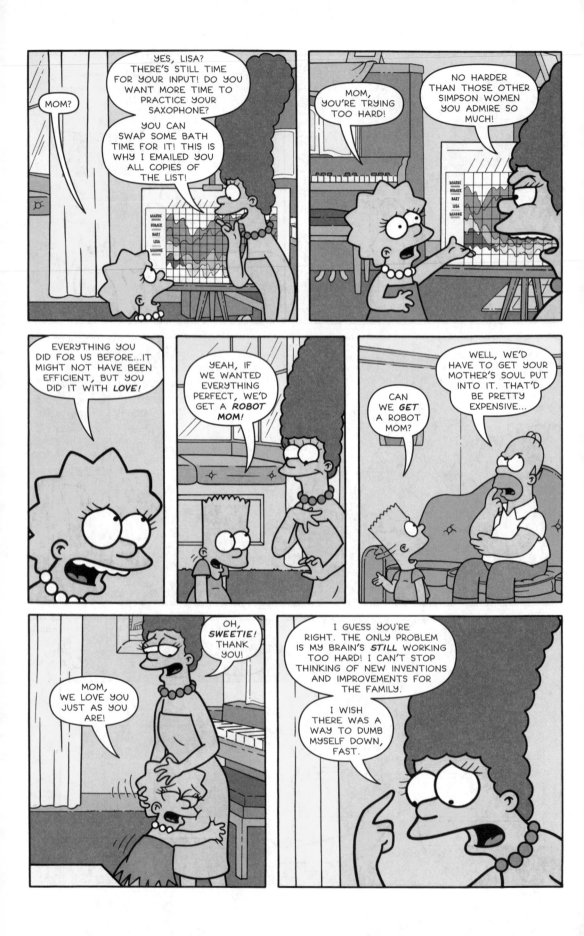

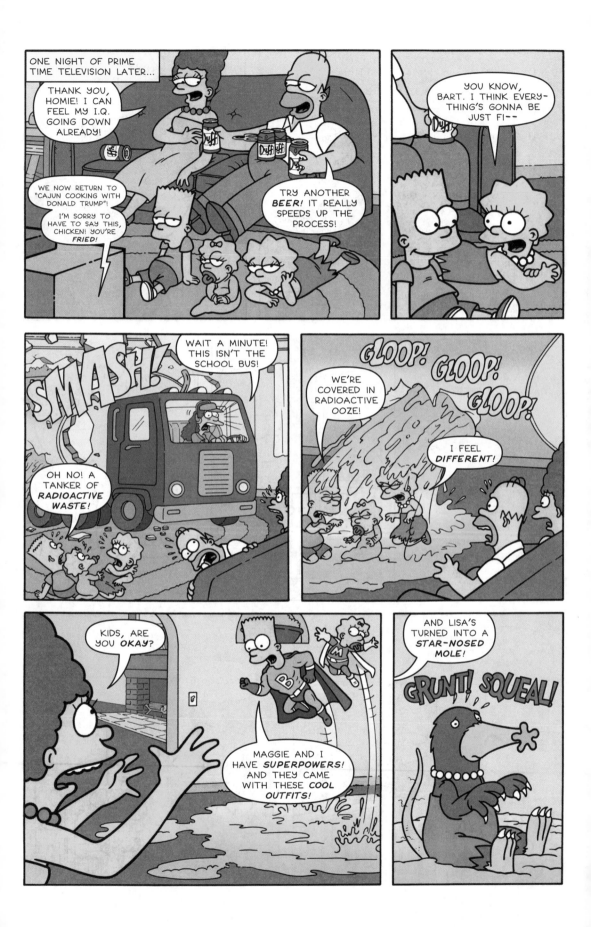

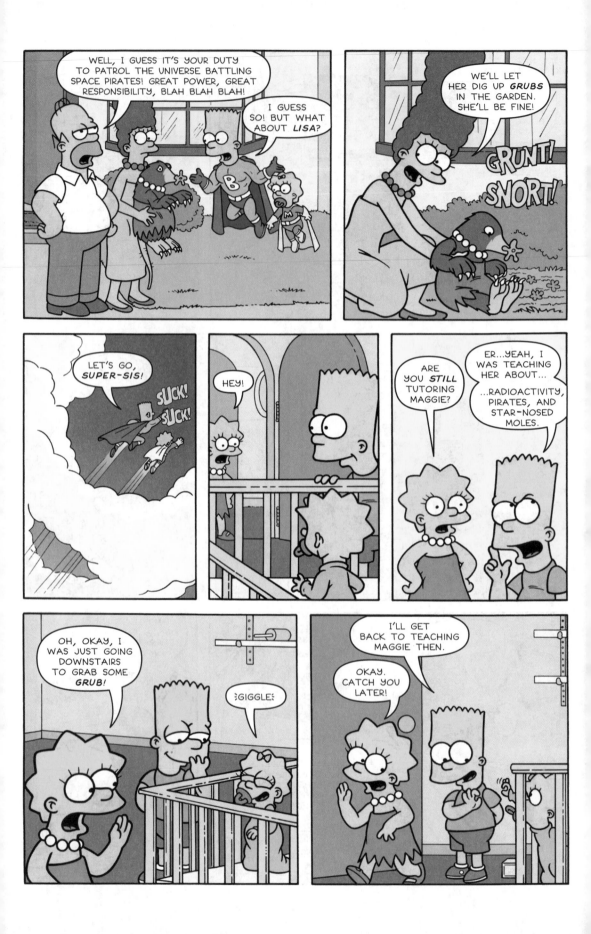

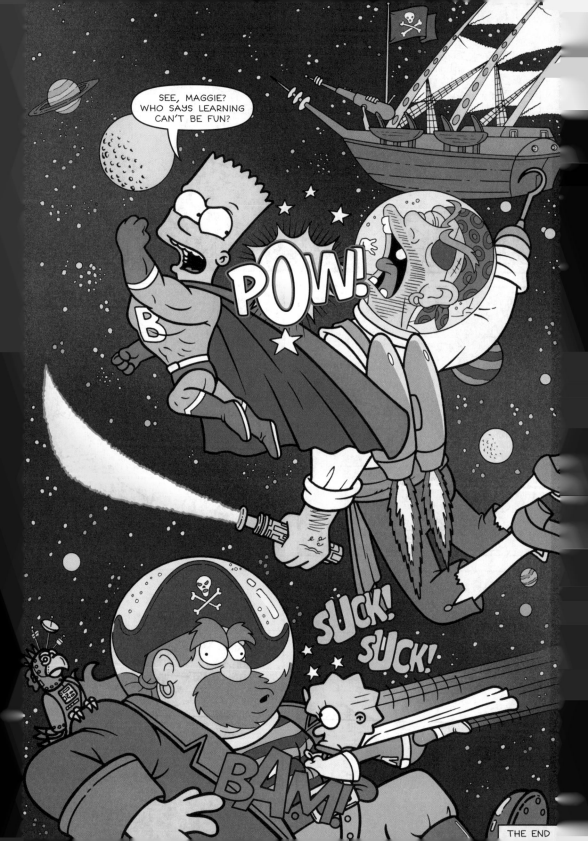

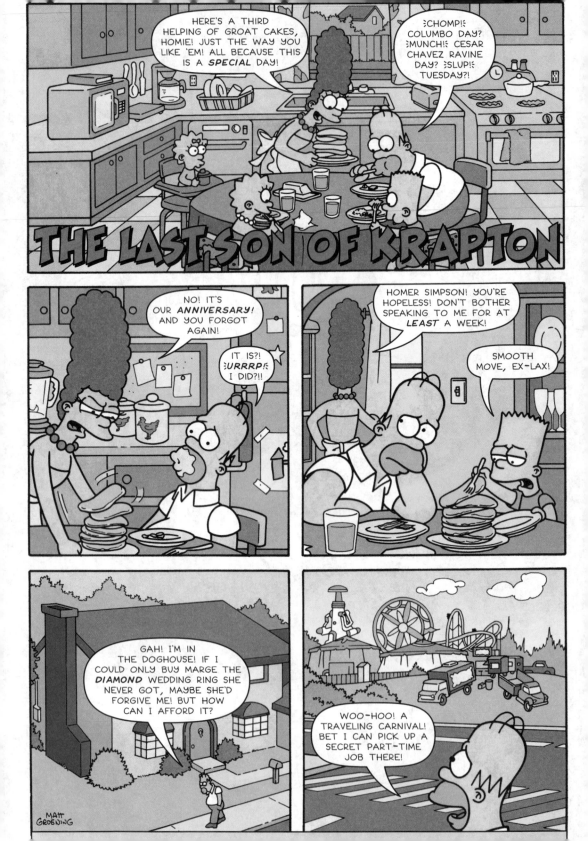

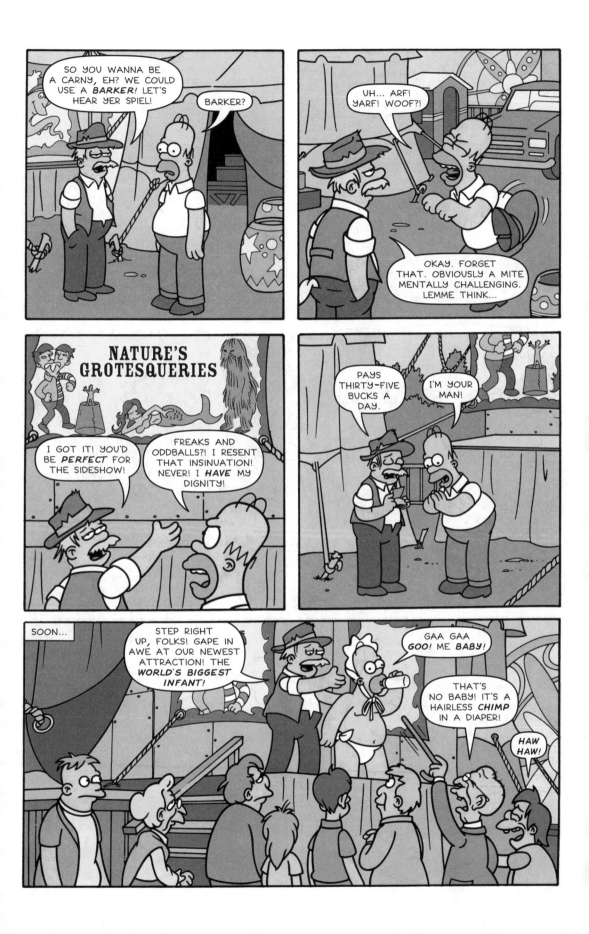

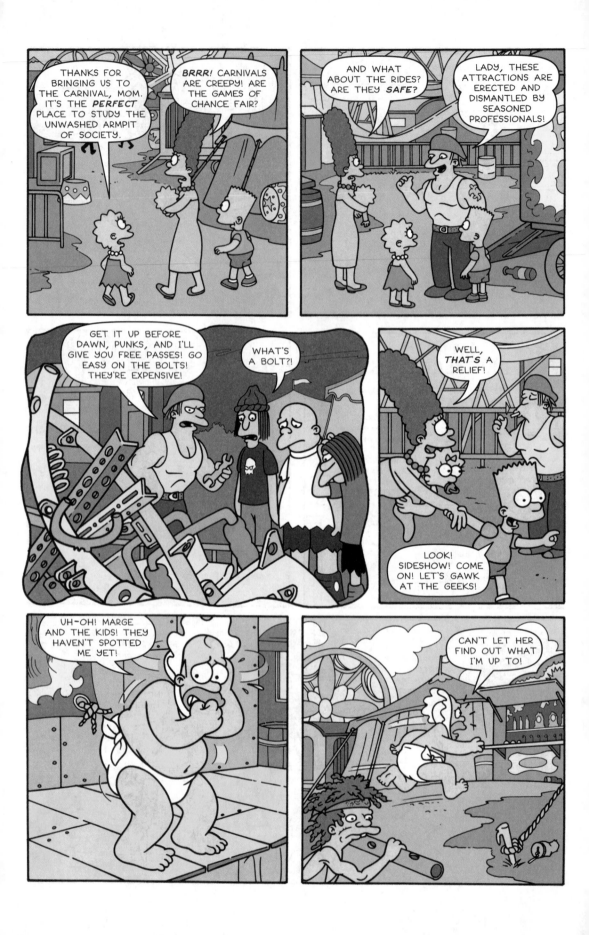

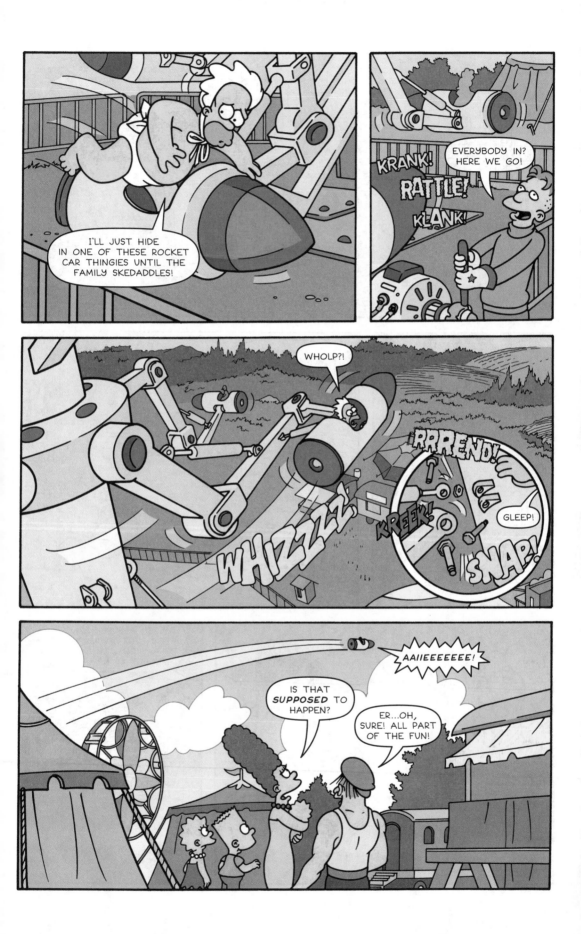

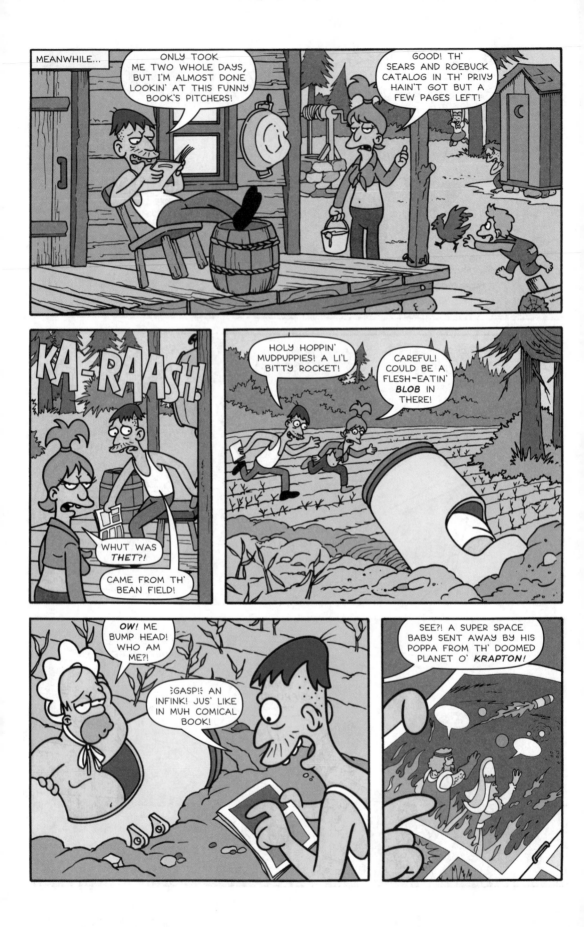

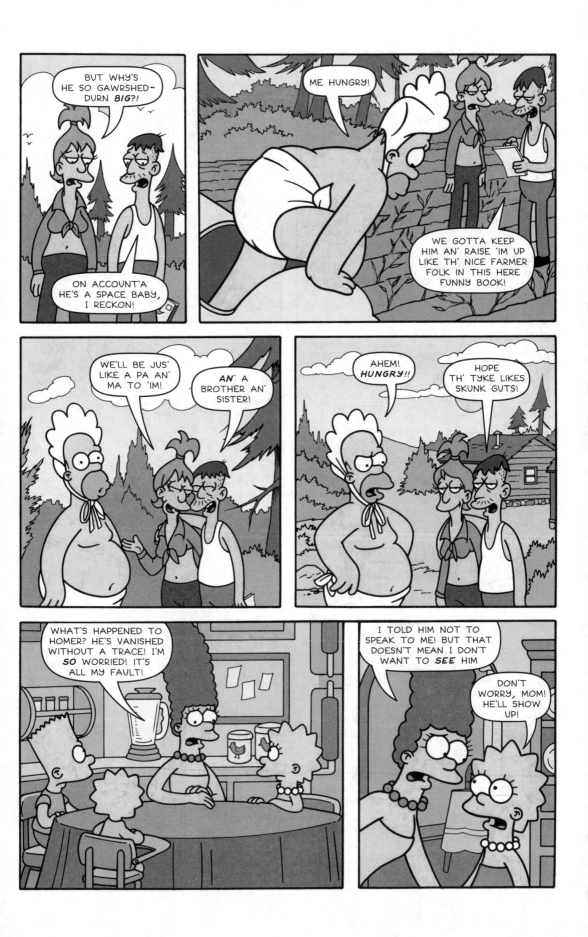

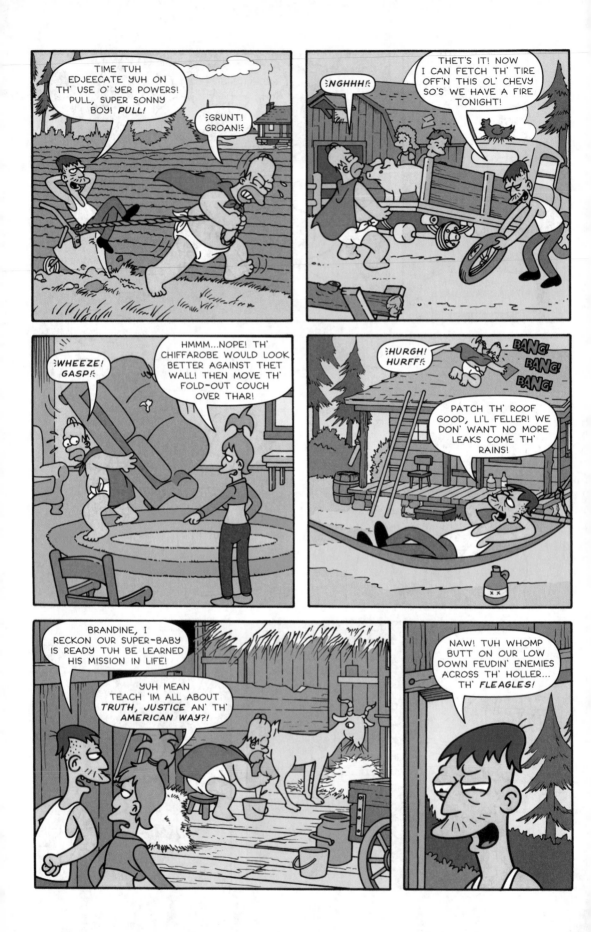

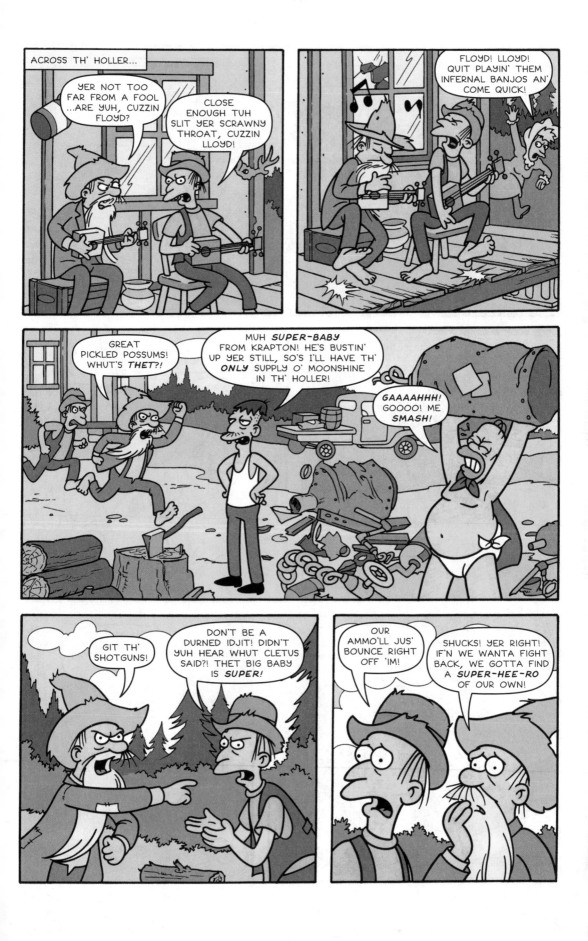

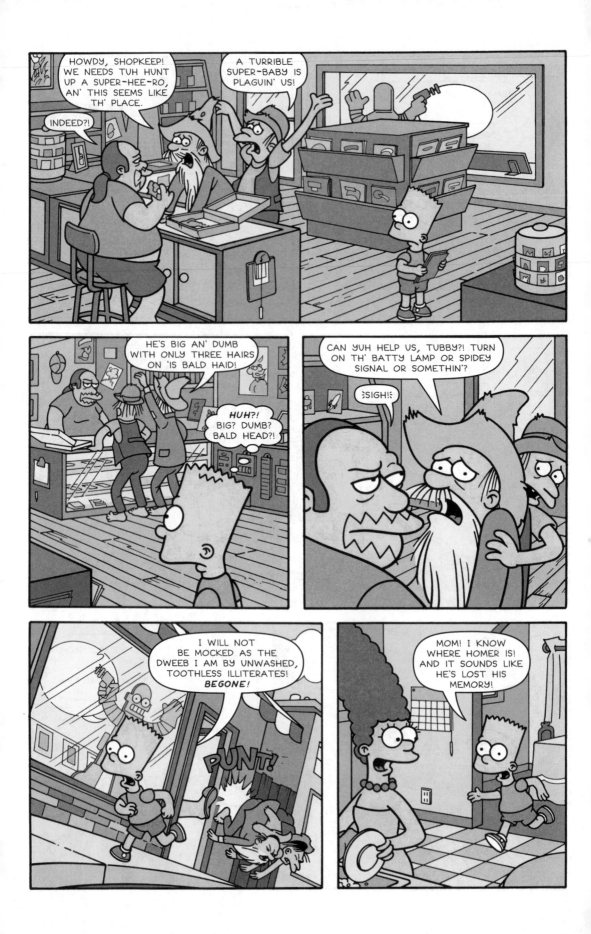

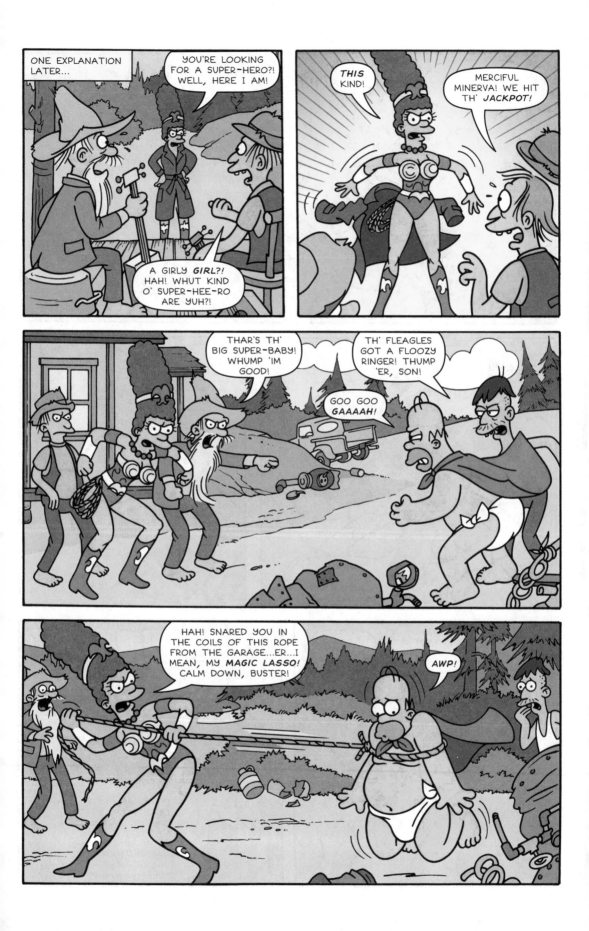

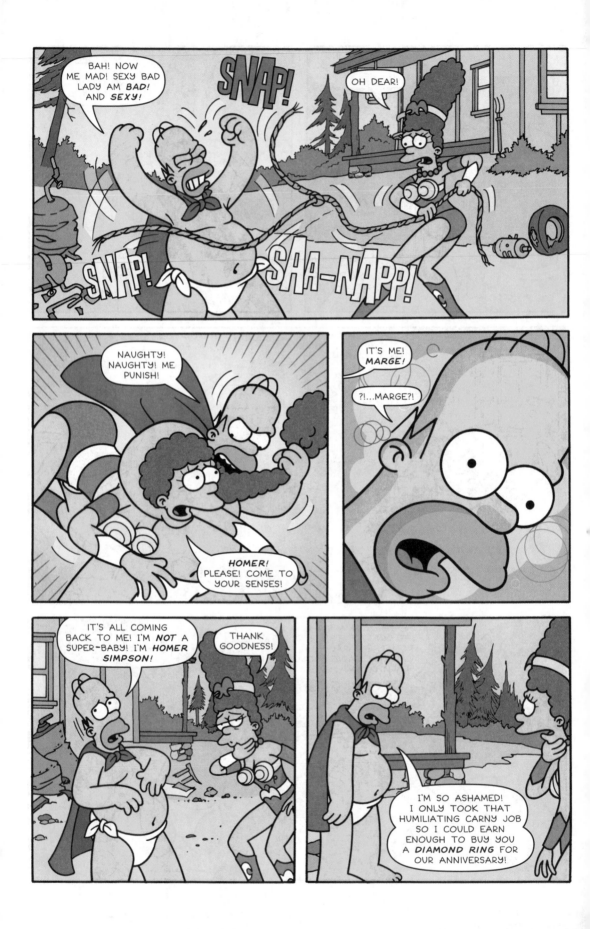

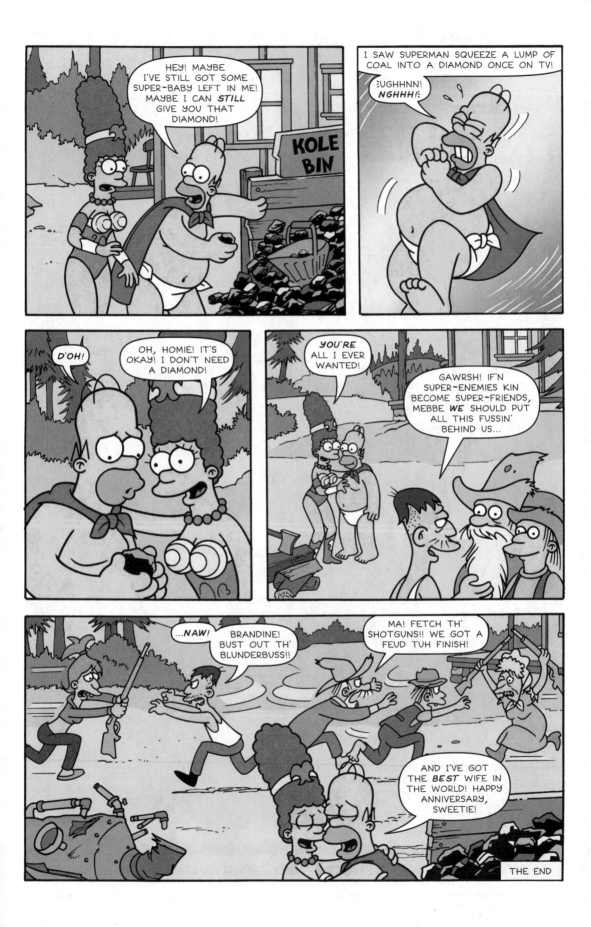

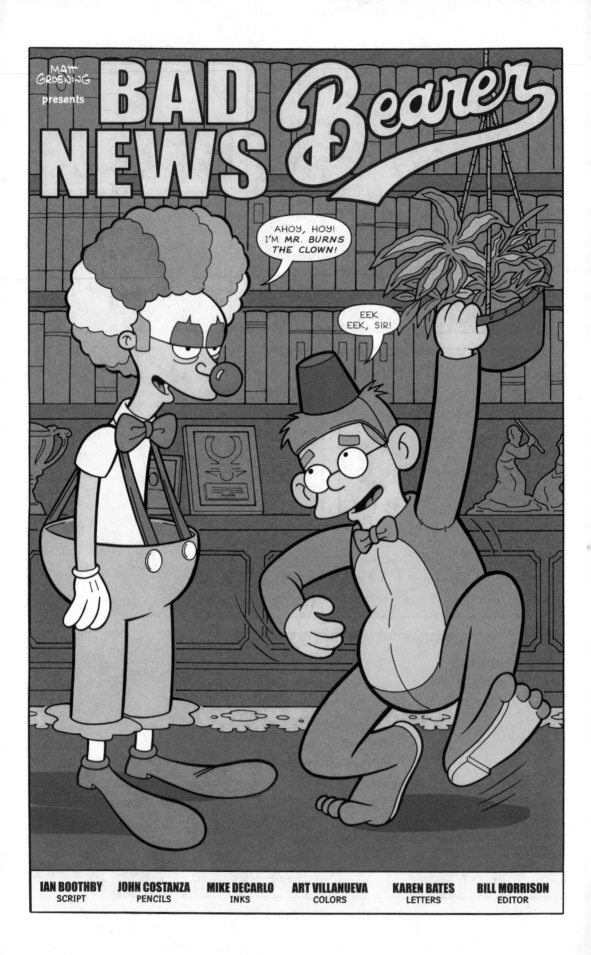

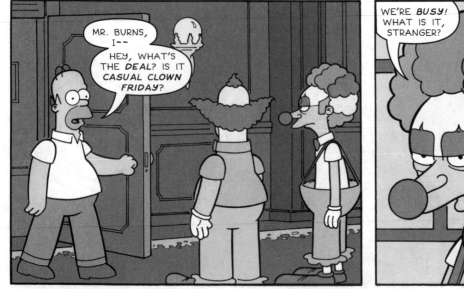

MR. BURNS, I-- HEY, WHAT'S THE *DEAL?* IS IT *CASUAL CLOWN FRIDAY?*

WE'RE *BUSY!* WHAT IS IT, STRANGER?

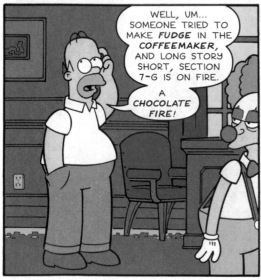
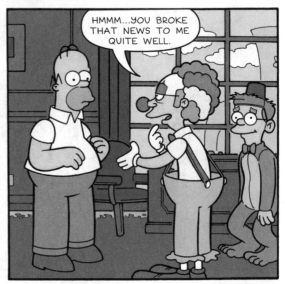

WELL, UM... SOMEONE TRIED TO MAKE *FUDGE* IN THE *COFFEEMAKER,* AND LONG STORY SHORT, SECTION 7-G IS ON FIRE.

A *CHOCOLATE FIRE!*

HMMM...YOU BROKE THAT NEWS TO ME QUITE WELL.

WELL, IF YOU'RE IN THE MOOD FOR BAD NEWS, SOMEONE PLUGGED THE EMPLOYEE TOILET WITH A *BASKETBALL,* AND THE PIPES BURST.

BUT THE GOOD NEWS IS, IT'S PUTTING OUT THE CHOCOLATE FIRE!

YES, YES, YES! THAT'S THE WAY TO BREAK BAD NEWS! HARLEQUIN, YOU'RE FIRED!

FINE! I HAVE A GIG EMCEEING A BURLESQUE SHOW ANYWAY.

KIDS, I'LL GET YOU INTO THE CLUB, BUT YA GOTTA PAY FOR YOUR OWN *FAKE I.D.S!*

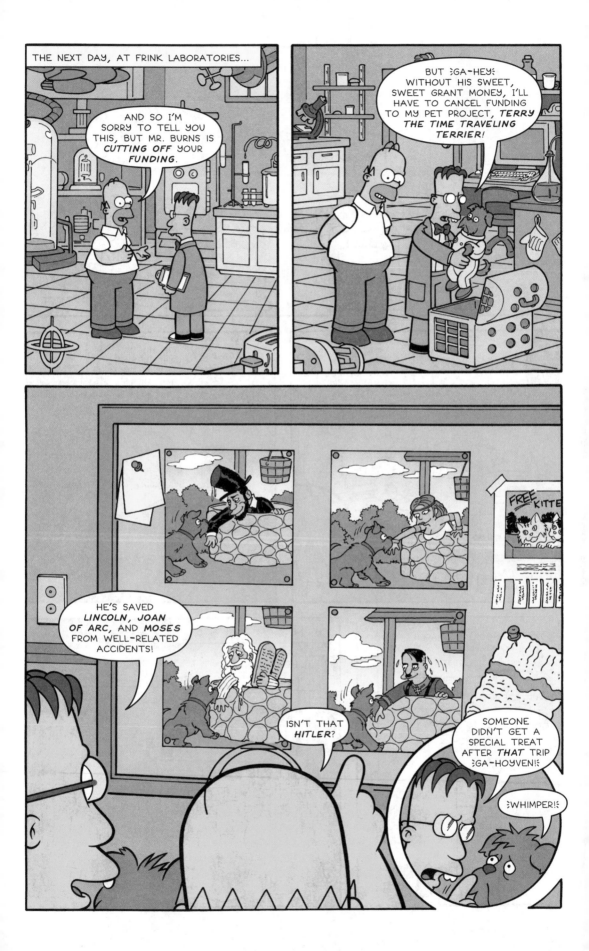

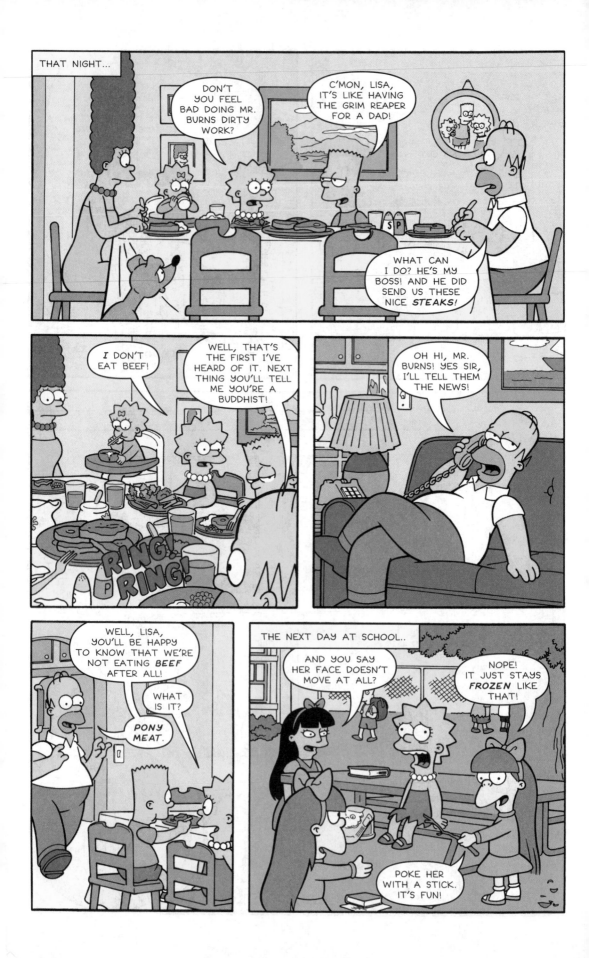

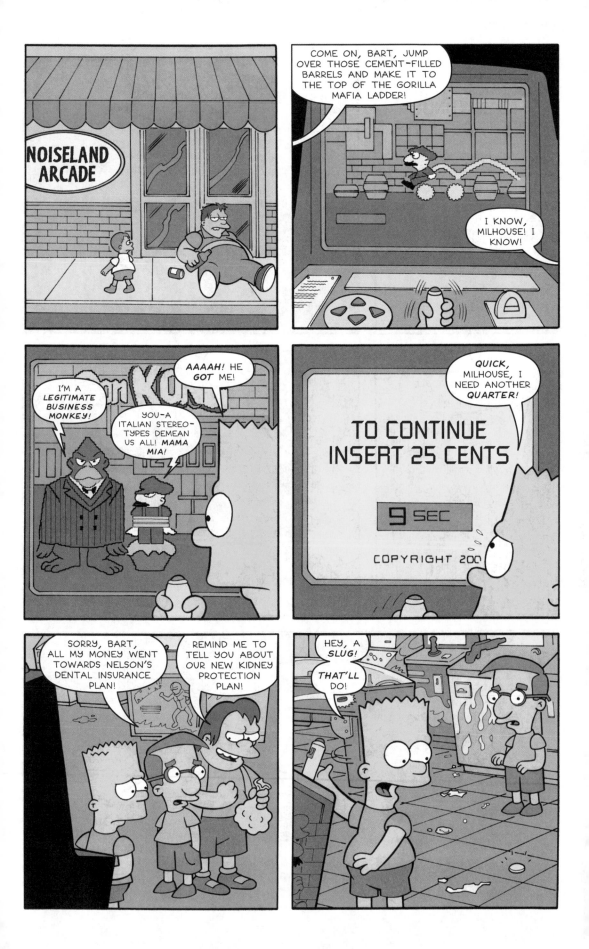

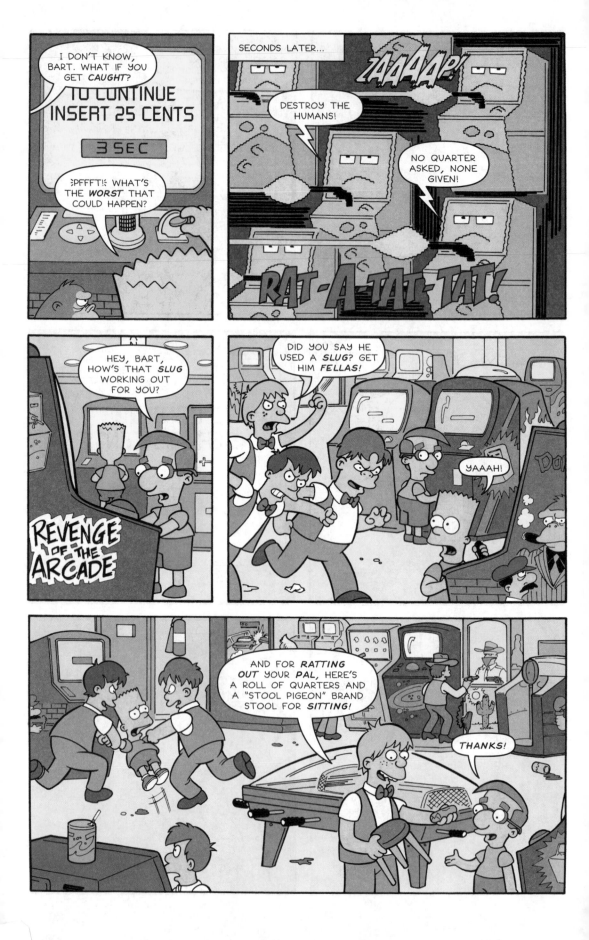

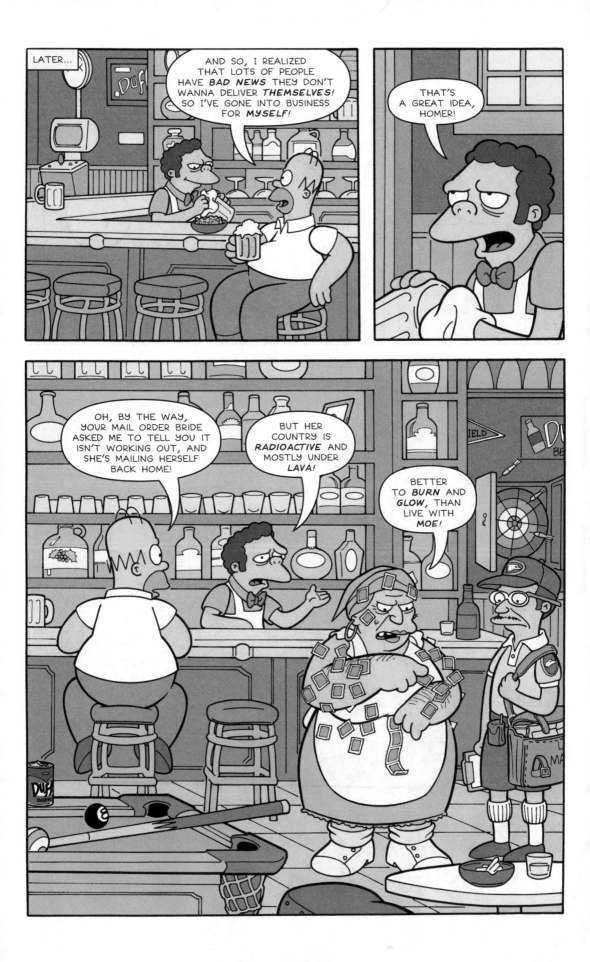

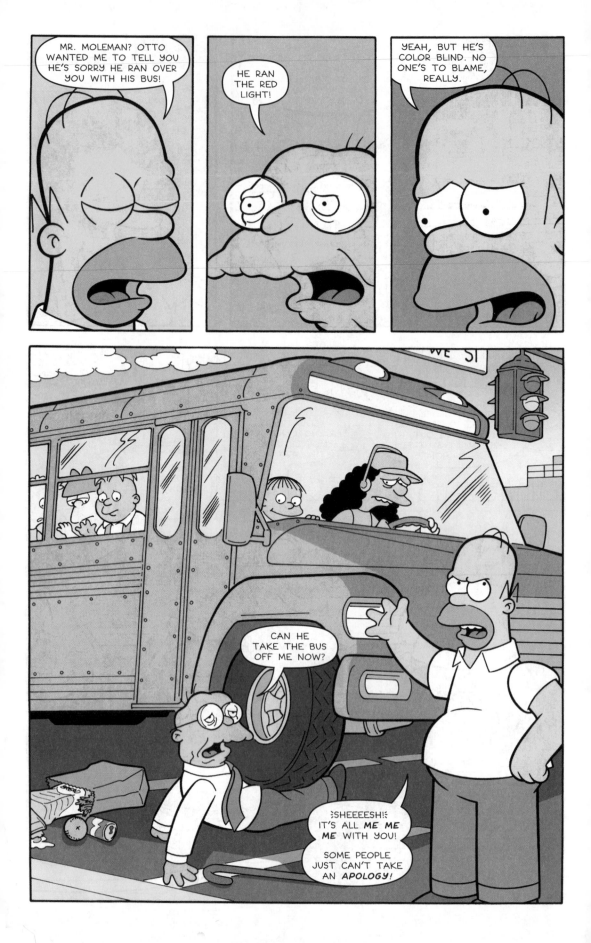

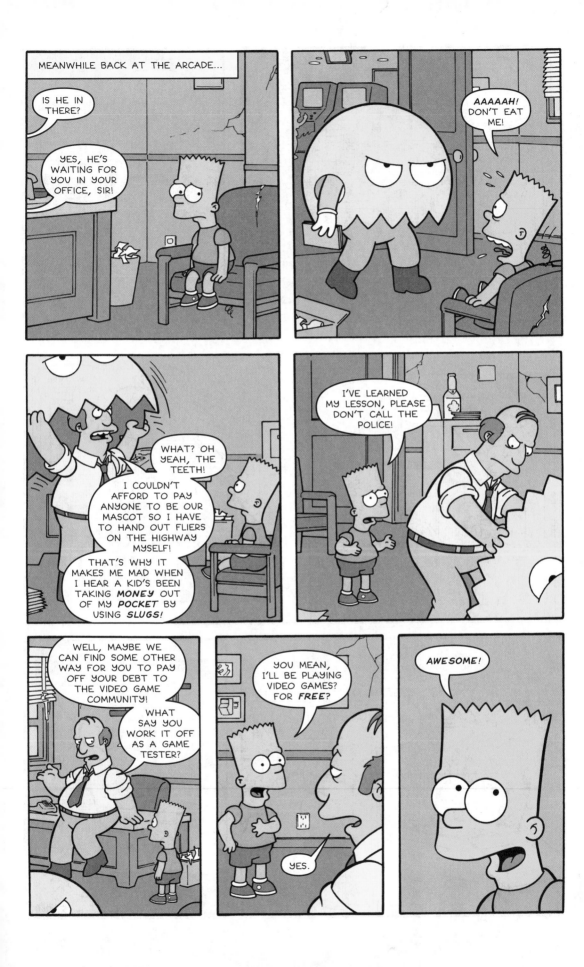

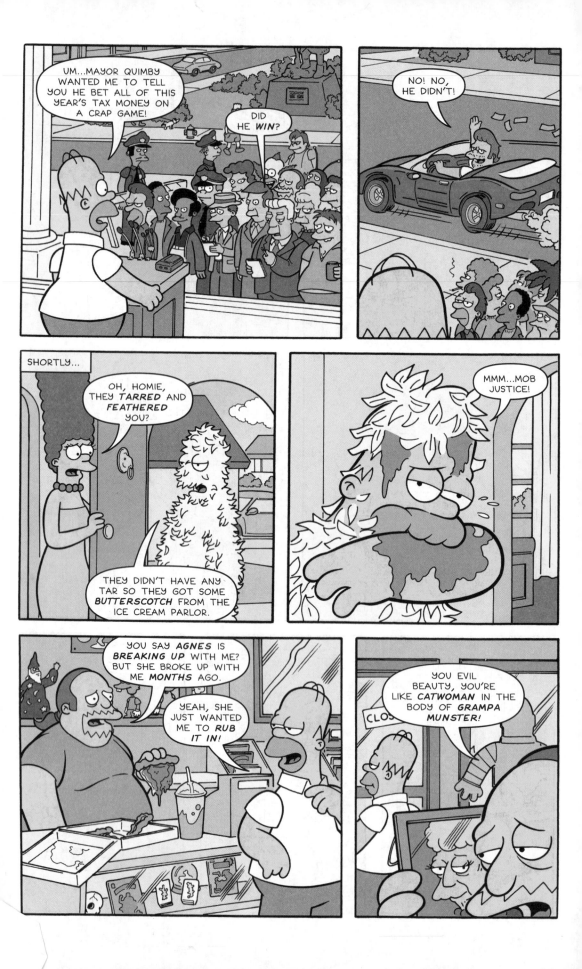

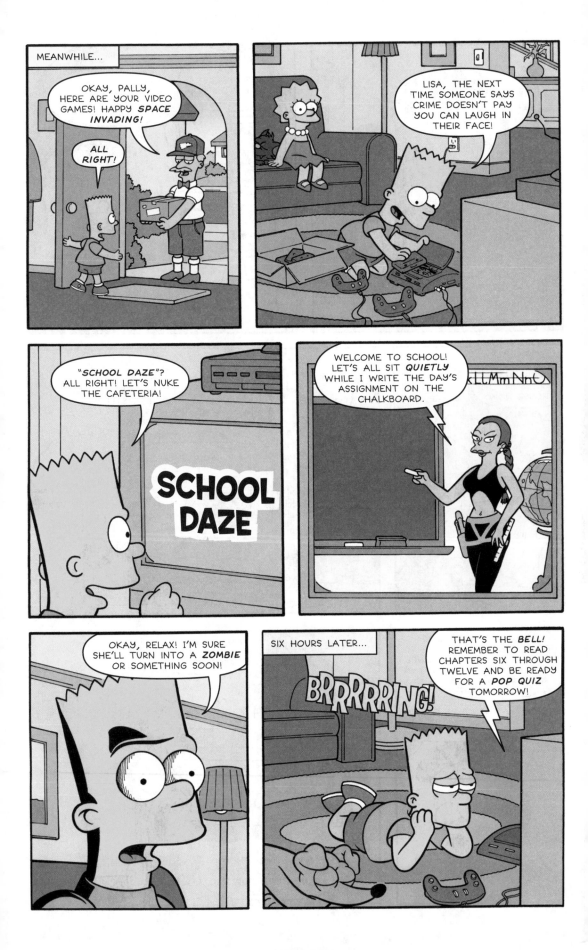

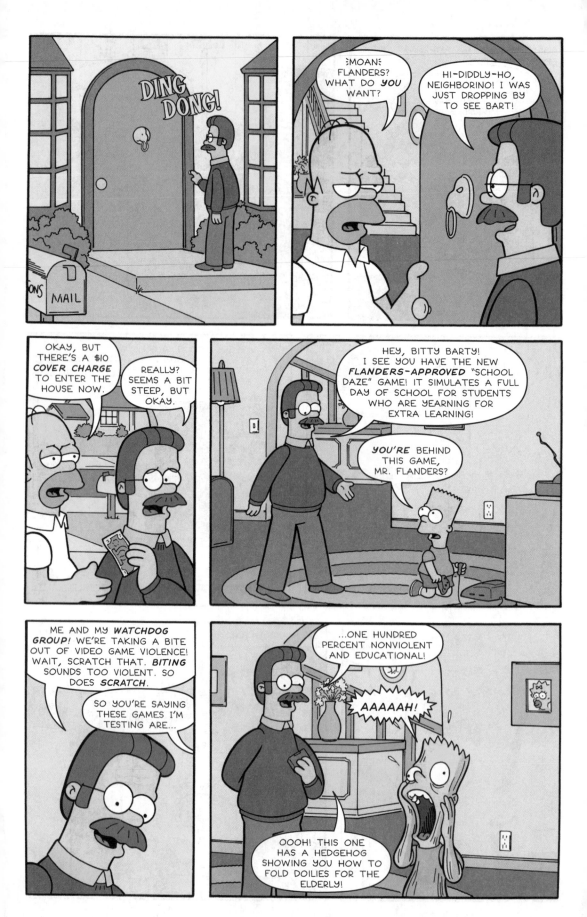

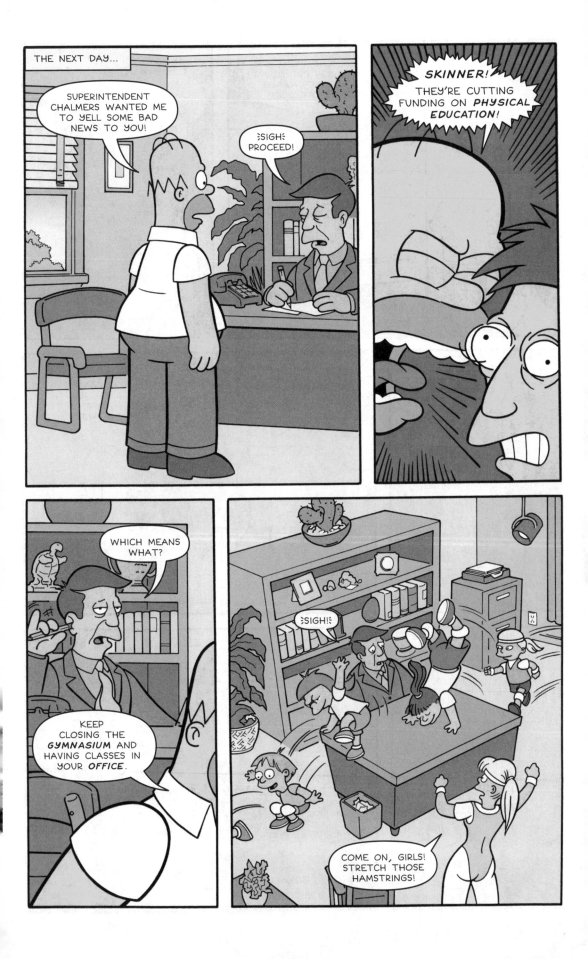

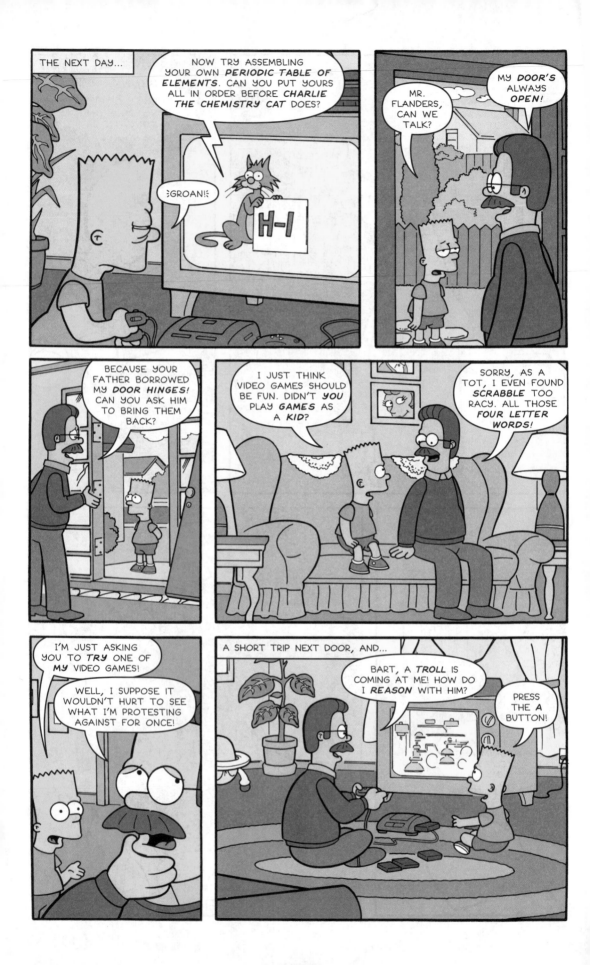

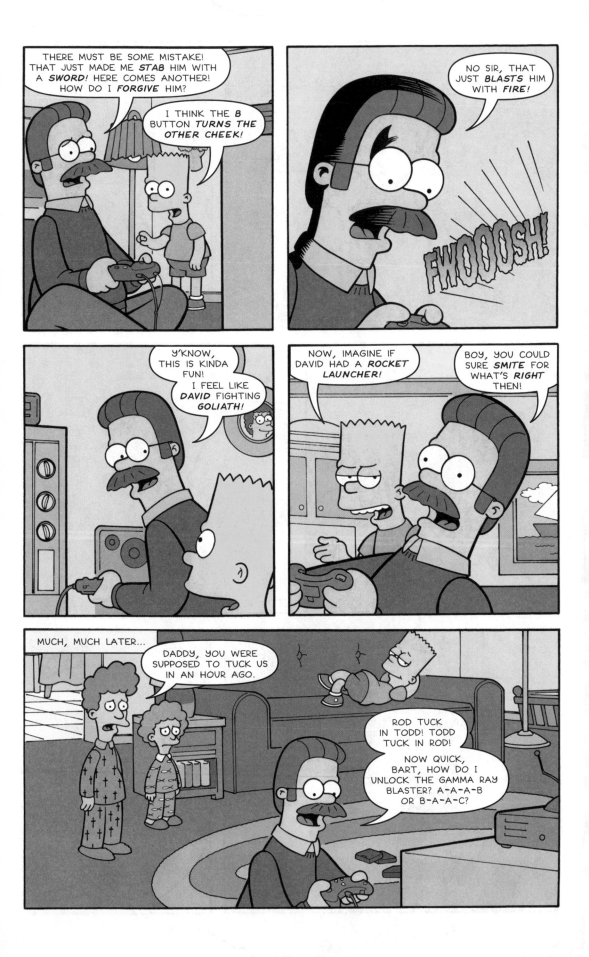

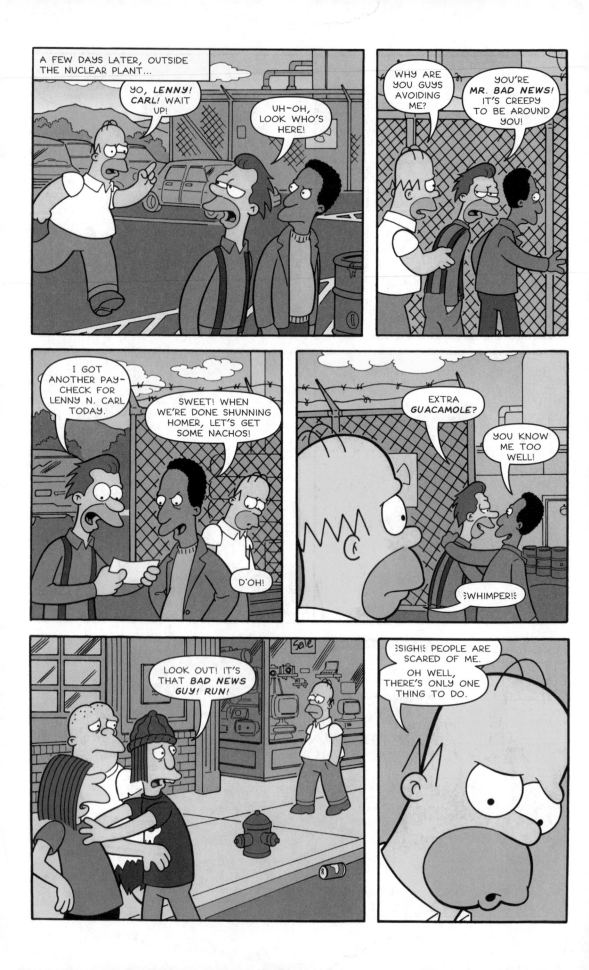

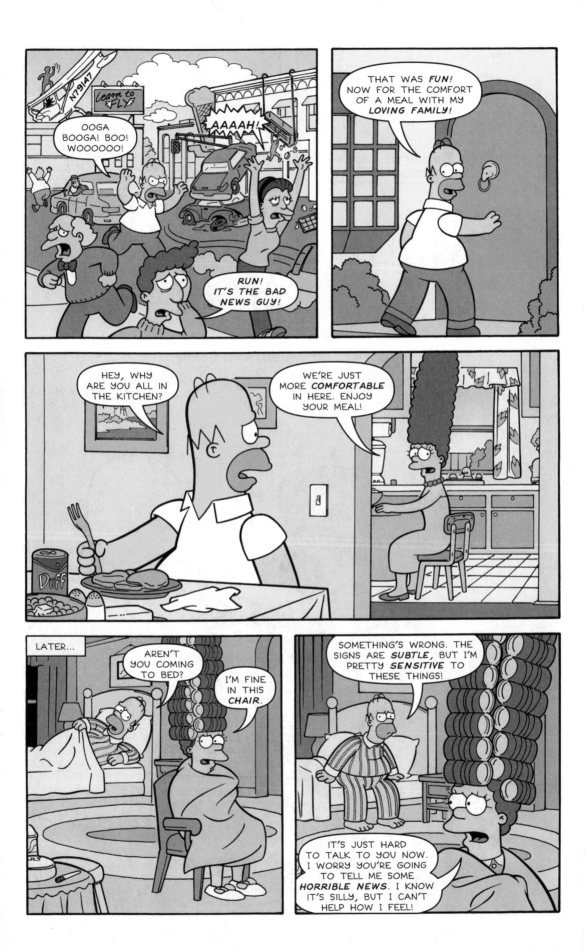

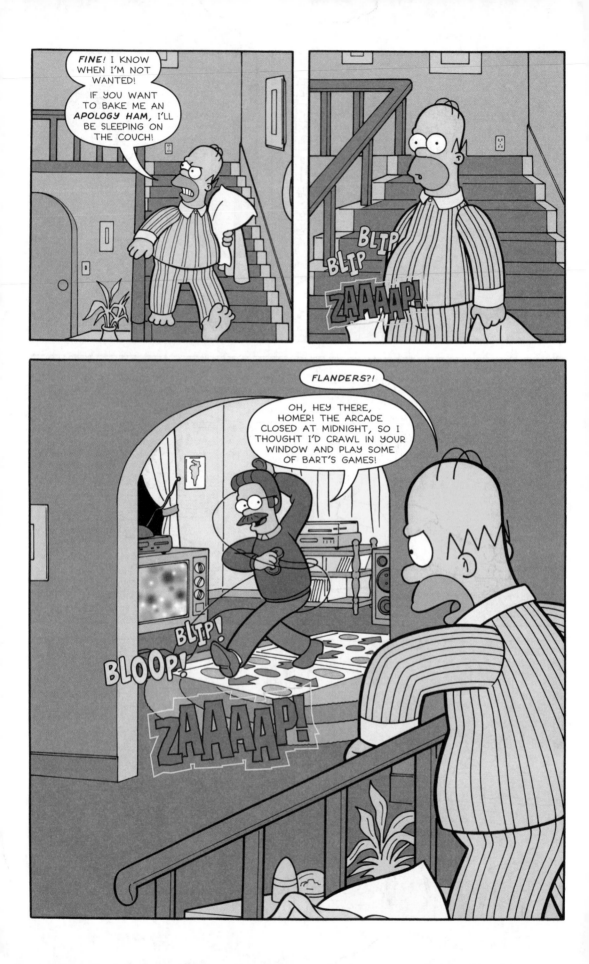

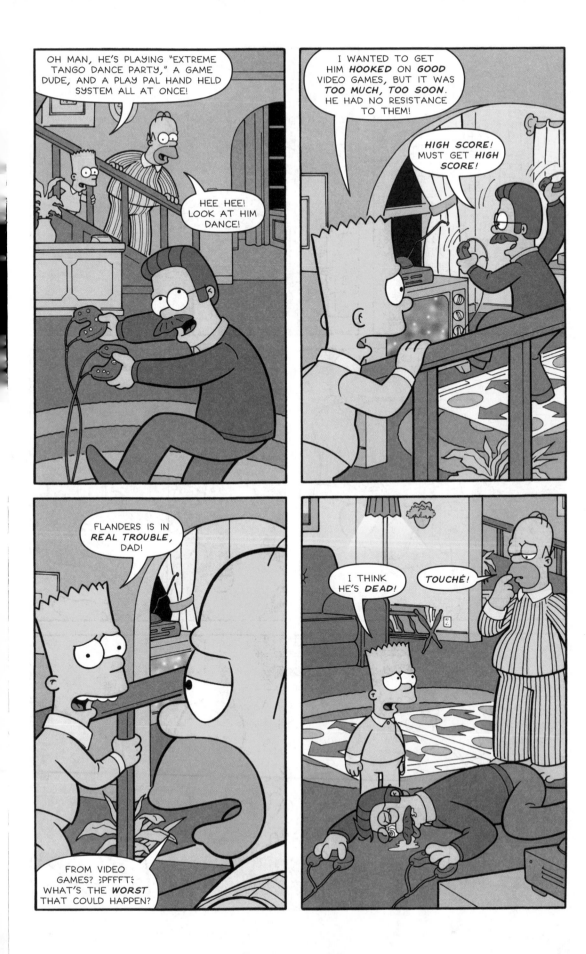

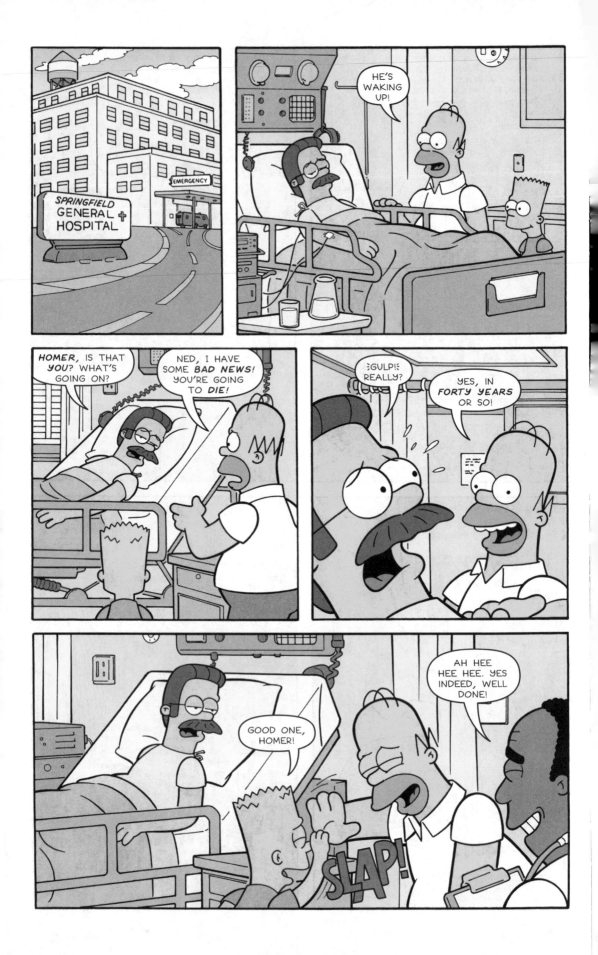

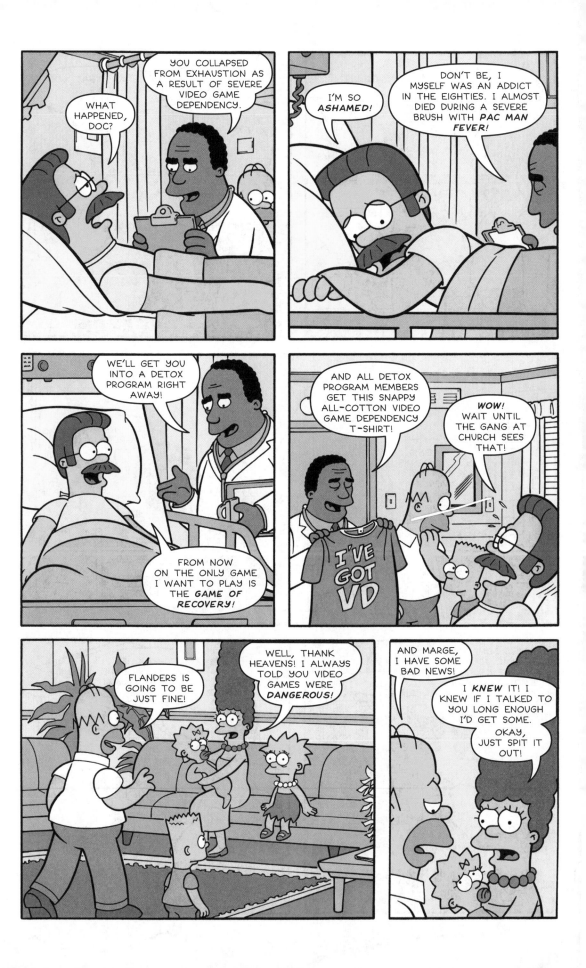

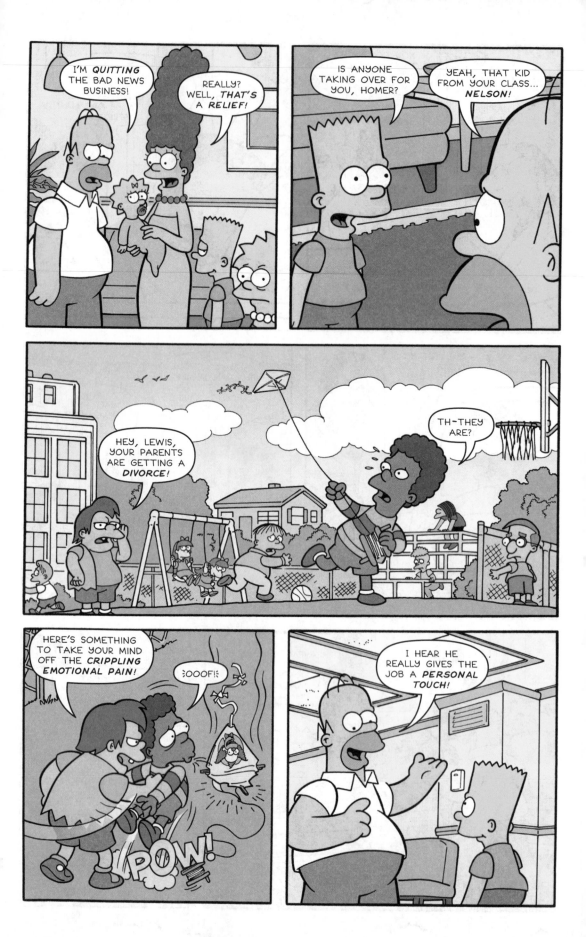

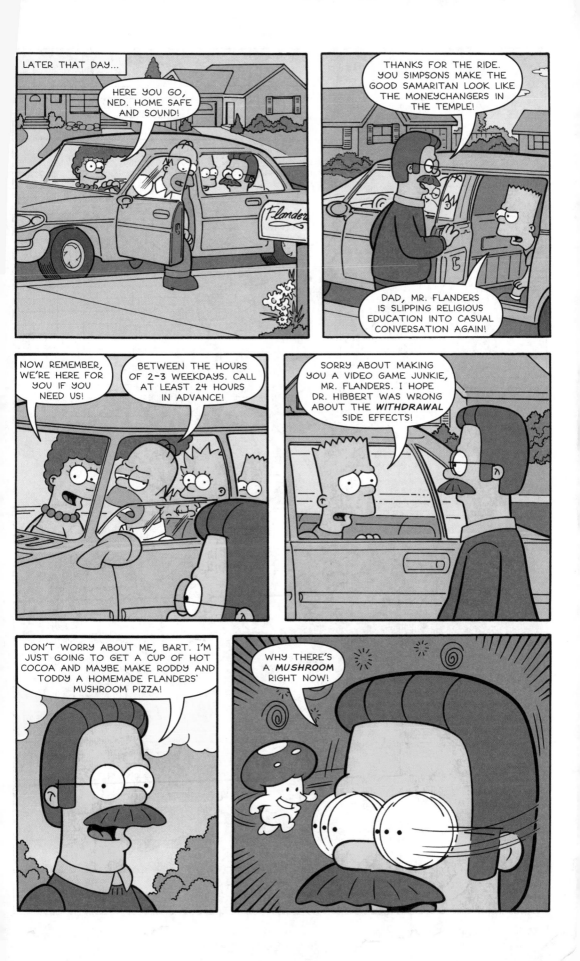

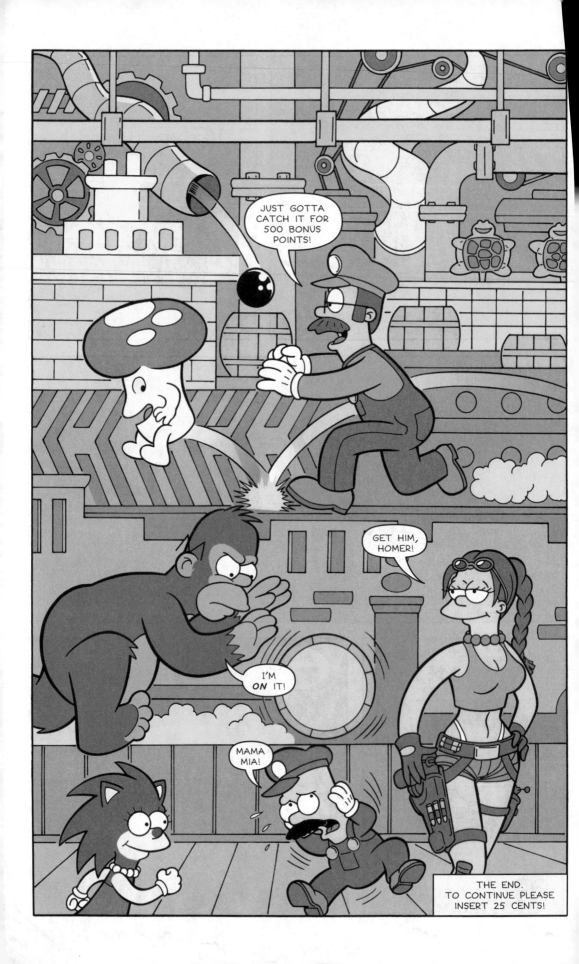